MAN RAY

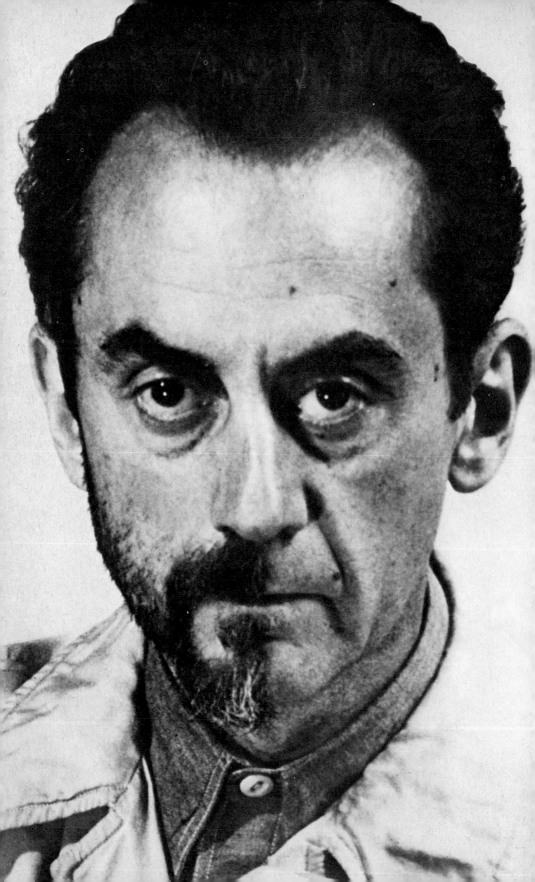

Roland Penrose

MAN RAY

with 154 illustrations
20 in color

NEW YORK GRAPHIC SOCIETY

BOSTON

First published in England by Thames and Hudson, Ltd.
Published in the United States of America by New York Graphic Society, Ltd
11 Beacon Street, Boston, Massachusetts 02108

International Standard Book Number
0-316-54489-2 CLOTH
0-316-54487-6 PAPER
Library of Congress Catalog Card Number 74-27250

PRINTED IN GREAT BRITAIN

Contents

For Lee

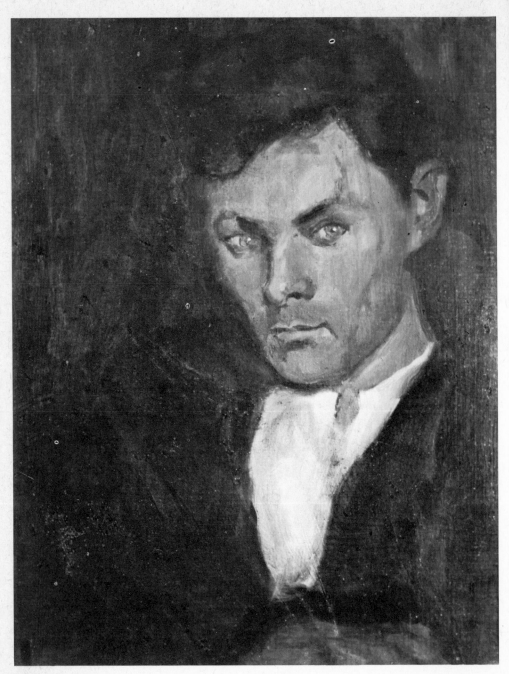

1 *Portrait* 1909

1 Philadelphia – New York
1890–1921

In the beginning

When the midwife finally opened the door, all she needed to say to the anxious father was, 'It's a man.' With these words, Man Ray was ushered into the world in Philadelphia, on 27 August 1890, with the rare distinction of having his birth and sex announced and being named in the same breath. Of his father we know little more than the fact that he made his own violin, on which he played Russian folksongs, and that a week after their marriage he and his wife parted, seized by panic at the probable consequences of their union. But chance, that element that was to be of capital importance in Man Ray's later years, brought them together a year later with more fruitful results.

We know a great deal more about Man Ray himself than about his origins, which have always been shrouded in mystery. No one has ever managed to elicit from him the history of his family, which he affirms is long forgotten and better so, since it could only be a cause of embarrassment, both for his ancestors who would have to admit him to be their heir and for Man Ray who would have to recognize their seniority. One has the impression that, like Adam, Man Ray was the first of his race. We are left with the pleasure of following the life of an individual, unhampered by the extraneous details of the family. This makes it easier, not only to concentrate on the richness and variety of his work, but also to study the originality of his genius which was liberated by his early determination to find his own path.

Recently Man Ray produced an autobiography, *Self Portrait*,[1] outlining the first seventy-three years of his life. He describes it

modestly as captions or subtitles to the continuous flow of images of which life is composed. Yet 'never', he says, 'have I engaged in such a sustained effort over one work as in the writing of this book.'[2] It is written as though he were telling a story, rapidly, with zest and without going back to make corrections. Having devoted his life to the visual arts, he discovered suddenly a desire to supplement his work with words. In my attempt to understand and present the life and work of Man Ray, from its most simple to its most complex aspects, I shall make unstinting use of this illuminating book. It is rich in detail gleaned from a remarkably clear memory and I am fortunately able to vouch for its accuracy in the latter half of the book, having participated in many of the events as a result of the generous friendship which he extended to me in the thirties, when I was an enthusiastic young Surrealist with an eager appreciation of his work – a friendship which still continues.

At the turn of the century there was no great difference between Europe and America in their generally favourable attitude towards the visual arts. In both continents the arts were treated with conventional respect as a sign of riches and progress. The function of the arts was to reflect the increasing wealth brought by commerce and industry. Truth and beauty based on classical standards were to be their ultimate goal. The discoveries of science were expected to open the path to a prosperous society in which harmony was to be imposed by compliance with a strict moral code. But the twentieth century shattered these expectations and our pious ancestors were shocked to find that a fundamental factor in the ensuing changes was the refusal of artists and poets to endorse ideas which were proving to be false and sterile.

With deep conviction among a small minority, the sense of a necessity to revolt against a complacent and corrupt society took root. Now, after three-quarters of a century, during which revolution in one form or another has changed radically our

ways of living, it is difficult to realize the courage and the imagination that was needed. For the early pioneers it was a hard struggle upon which they embarked to liberate themselves from the past and to offer a conception of art which was new and yet sensitive and responsive to the most ancient and primitive of its forms. Their aim was, on both sides of the Atlantic, to overthrow the tyranny of the then fashionable academic salon and to create an attitude towards the arts based on the reality of human desire. A movement so revolutionary in its incentives was unlikely to come from an élite already satisfied and intent on preserving its traditions. Instead, it sprang from the few who were dissatisfied with the inequality of their social conditions and hated instinctively the lack of vision and the hypocrisy in which they found themselves submerged.

Time has radically changed the attitude of society towards these early pioneers. Once despised and considered ridiculous or dangerously subversive, many of them are now crowned with success and popularity. The change is so remarkable that it is necessary to remind ourselves that the visionary mission to which they subscribed, without pretension and with no path to follow except that which demanded courage and clairvoyance, was dictated not by their intellectual research but by their instincts and desires.

It is true that the energy and inventiveness which contributed to their impulsive actions were given an incentive which is often lacking when there is no opposition from an established and zealously guarded order. Indifference is the most deadly poison for the arts; the young revolutionaries in the first decades of this century could rely on the fury provoked by their attitude in all the ramifications of Church, Press and Establishment to create a fertile atmosphere in which, despite opposition and obstinate misunderstanding, their work could gradually enter the consciousness of ever-widening circles.

But the scandal that their activities produced was not their prime objective. It was an attractive by-product which served

to keep their impact sharp and to provoke new trains of thought. The most effective and sustained activity, the most lasting in its influence, was the result of two different motivations. There were those who, with dedicated zeal and sincerity, wished to make in their work a contribution to the improvement of our human lot – the purists whose desire was to escape from ambiguities and confusion through abstract perfection. There were others who accepted the whirlpool of contradictions and absurdities in order to enjoy the perilous game of life in which reality and truth together lie hidden. With detachment and varying degrees of cynicism, they explored and enjoyed the absurdities and mysteries around them and arrived, by chance rather than by calculation, at new levels of understanding, at ideas that startle us by their novelty and their unexpected insight. Marcel Duchamp defined Man Ray in these terms: 'MAN RAY *n.m. synon. de joie, jouer, jouir*' (joy, play, enjoy), a description which makes clear his allegiances.

Early discoveries

We know of at least one event that interrupted the normal growth of Man during his childhood in Philadelphia. He tells us how, with an awakening taste for experiment, he deliberately smeared all over his face the wet paint from the newly decorated doors of his home, and how he induced his friends to do the same. His delight in this early and daring use of paint, and the 'cold blooded whipping' from his father that followed, remained in his memory. The criticism his ideas were bound to provoke, however, was in general to act on him as a stimulus rather than as a deterrent.

When Man was seven, the family moved to Brooklyn, which in those days was a suburb joined to Manhattan Island by the famous Brooklyn suspension bridge, much admired by painters. From there, the noisy tentacles of industry reached out into green fields and farms. For his birthday, Man remembers

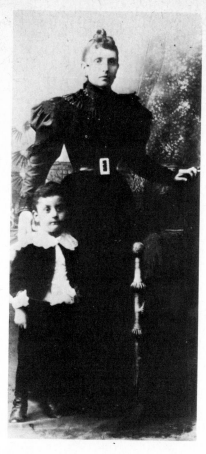

2 Man Ray with his mother 1895

receiving from a cousin his first box of coloured crayons. The gift coincided with an event of national importance, widely publicised in the press: the sinking in the Cuban War of the great U.S. battleship *Maine*. Man describes how he found great pleasure in copying a black and white photo with his coloured chalks. He enjoyed the freedom of creating his own version, in colours so daring that they brought immediate reproach from those who thought they knew better.

In retrospect, both these anecdotes point perhaps to Man's early desire to become a painter, or rather to use colour and images in unconventional ways. It became urgent for him to use his nascent faculties and so he built up a store of pencils, colours and brushes by petty theft from local shops. Life in the crowded streets of Brooklyn was seething with adventures.

Dogs, cats, horses, mice and cockroaches, as well as the behaviour of his own playmates, had to be examined and noted; new types of machines, engines, bicycles and unheard-of contraptions brought continual surprises. But for Man, the young observer of this pandemonium, what mattered was his ability to notice and record what he saw. He received in this no encouragement from his parents who, practical and cautious, saw no future for him in that direction and dreaded finding that they had a penniless artist on their hands.

It became necessary for him to develop his own resources and discover the world by himself. 'Looking back', Man tells us,

I cannot help admiring the diversity of my curiosity and of my inventiveness. I was really another Leonardo da Vinci. My interests embraced, besides painting, human anatomy both male and female, ballistics and mathematics in general. For the first, I used my brother, two younger sisters, and casual playmates as guinea-pigs. One outraged little girl complained to her mother and I received a thrashing, which I almost enjoyed; was I a budding sadist and masochist?[3]

He goes on to describe the small iron cannon with which he tried to make a half-dead mouse airborne by tying its tail to the charge, and his disappointment in finding that it only flew a few inches. Also, there was the splendid locomotive he built, with its realistic stove-pipe chimney. This led to further frustration when he found it had been smashed to pieces by his mother, who preferred to disappoint him in this way than to see him smashed to bits by the traffic in the street outside their house.

His resourcefulness in more homely ways, such as making lampshades, won him the appreciation he needed at home. His real difficulties began, however, when at the age of fourteen he was sent to high school. These problems arose in the first place because of the encouragement given him by the art master, who was 'an artist in every sense of the word'. Recognizing the talent

of his pupil, he covered him with honours which earned for him the animosity of his class. A similar embarrassment was the kindness and intelligence of the teacher of mechanical drawing, from whom Man learnt the fundamentals' of architecture, engineering and lettering. It was due to him that Man developed his powers of drawing in a way that later made it possible for him, not only to earn his living, but also to create a style of his own which was free from the conventional 'aesthetic implications' of painting. However, his success at the time in those realms that fascinated him was not equalled elsewhere and he had the greatest difficulty keeping pace in such subjects as history, which he could understand only by visualizing it as a pictorial map.

Despite his uneven scholastic accomplishment, he was awarded a scholarship in architecture at a New York university, much to the delight of his parents, and was then free to spend his vacation painting alone indoors and outdoors. This new freedom, however, rapidly led to a dramatic decision. He announced to his parents that he was resolved to abandon his scholarship and find work on his own, so that he could continue to paint. He had had enough of schools and he wished to be free to make his own life.

The grindstone

Man's first employment was selling newspapers at a station on the elevated railway that served the business areas of New York. But one week of this was enough and he signed on elsewhere as an apprentice to learn engraving. In his *Self Portrait*, Man Ray describes the grimy workshop under Brooklyn Bridge where he was initiated in the tedious and exacting routine of engraving patterns on silver walking-stick handles. His companions repeated endlessly their copybook designs, but this was not enough for Man, whose ideas of engraving sprang from Rembrandt, Goya and Whistler; never following the same

pattern, he invented 'clusters of cherries and grapes with a bee or a butterfly now and then for variety'. The boss liked the seriousness of his application, but offered him such meagre hopes of an advance on the $3 he had earned in his first week that he again abandoned such drudgery and took a job in an advertising office in Union Square. There he had more scope to use his talents, and enough free time to join an art class and begin to draw seriously from life. This he did for some months until, unexpectedly, the advertising business closed down.

During this period he suffered another disappointment. His desire, awakened by a growing interest in sex, was to understand and possess the female body. Until then all he knew had come from furtive contacts with little girls, the fascination of Greek statues and the idealized nudes of Ingres. But on his arrival at the art school he was told that beginners had to draw only from antique plaster casts.

Again, thanks to his unruly spirit, a new solution offered itself. The instructor, who came to criticize the lifeless copies he was making from lifeless casts, noticed his sketches of the other students round the edge of the paper. He told Man that he might, if he 'hung around for a couple of years, improve and qualify for a silver medal', and added sarcastically that, since the impromptu sketch 'showed some interest and liveliness', he should go on working by himself. Man did not hesitate to forfeit his deposit and find another school, where he was confronted at last with 'a huge naked woman posing on a platform'. The first results were a mess and the instructor's reaction was, 'What is this, a horse?' Man silently agreed with the criticism, realizing that in order to understand the human form a certain knowledge of anatomy was essential.

In pursuit of this knowledge, Man accepted the invitation of a friendly medical student to visit a dissecting-room, where he could make drawings of corpses sent down from the morgue. With the example of his hero Leonardo to encourage

him, he set to work, but the stench and the inconvenience of the surroundings were hardly conducive to concentration and he resorted to the more comfortable study of books on anatomy before returning to the life-class.

Even then, his rendering of the human form did not suit the academic standards of his teacher, who next advised him to make a study of the Old Masters in the museums. In his enthusiasm for all that was new, Man had been inclined to neglect classical painting and focus his attention on the few Impressionist pictures that were finding their way into official art galleries. However, in a somewhat haphazard way he continued to find his own path, usually despite the instruction he received, which was controlled by a slavish observance of both academic tradition and commercial aspiration.

The ambiguity of the machine

After the closing of the advertising business, Man Ray found employment with a firm that published books on engineering. Their offices looked out across the Hudson River and his work required the use of his talent as a draughtsman trained in architectural and mechanical drawing. He found himself, in fact, confronting a problem of which artists have become increasingly conscious: the machine, that dominating presence of this century, which has created a love-hate situation affecting artists in many different ways. While the Futurists were captivated by its dynamic magic, Dadaists such as Picabia and Duchamp exploited its symbolic aspects with nonsensical humour, and Max Ernst also found in it a reason for ridicule.

At a very early age Man Ray discovered for himself the fascination of the machine which, by the time he began work in a drawing-office, demanded a precise and unemotional consideration of its structure and power. It was, at its best, a beautiful slave that could accomplish tasks which were burdensome to men. Man's interest in mechanical inventions, he

once confessed, stems from the fact that he is fundamentally lazy: an invention is justified if it can make his task easier. But the beautiful, obedient slave can become both a monster and a tyrant; the machine, Man realized, becomes dangerous when given undue reverence.

3 Man Ray's attitude became evident as early as 1920, in an object he made which was prophetic of his subsequent thought and work. It consists of a combination of cog-wheels, drawn with absolute precision and interlocked so closely that they immobilize each other. Above them the word 'Dancer', which can also be read 'Danger', dominates the composition. The object was realized with impeccable accuracy on a sheet of glass. It is a conundrum in its title and in the contradiction it presents as a working drawing of functional machinery which cannot work. It illustrates with precision Man Ray's reverence and distrust of the machine god, a duality of attitude he began to experience in the office that dominated the Hudson River.

During these years, however, Man was not absorbed entirely by visual or scientific experiences. He began to explore drama, music and opera, finding his way to performances of Bernard Shaw and Oscar Wilde and watching with delight Isadora Duncan, while in music the resemblance between mathematical drawings and the rhythms of Bach did not escape him. His horizons were extending and he sat at his desk watching with envy the great liners in the Hudson River leaving for Europe and wondering when the day would come for him to depart with them. Although he was becoming increasingly conscious of the delights that New York could offer, he felt also a sense of its deficiencies and a restless desire to probe beyond its limits.

A voice in the wilderness

'There is certainly no great art in America today; what is more, there is, as yet, no genuine love of it.'[4]

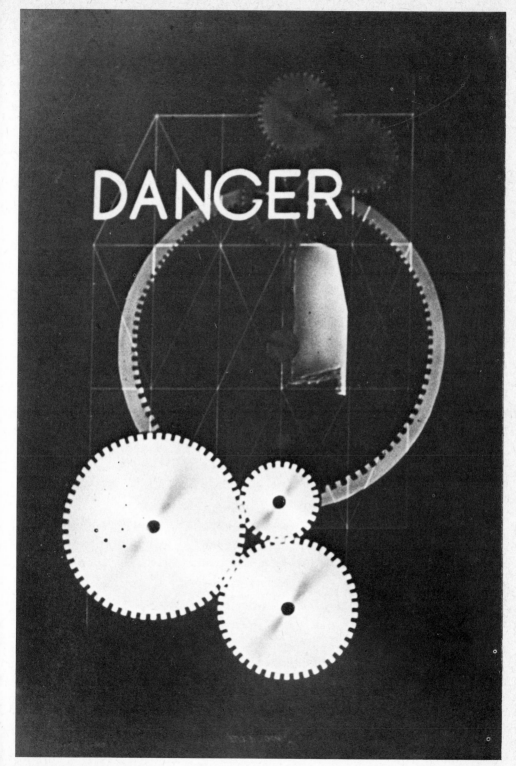

3 *Dancer (Danger)* 1920

This statement can be found in a letter written by Alfred Stieglitz to the art historian and critic Sadakichi Hartman, in December 1911. In 1905 Stieglitz, with the help of a group of photographers, had founded the Photo Secession Galleries in the little attic of a brownstone house at 291 Fifth Avenue. For twelve years this was a unique source of inspiration to the *avant garde* of New York. In 1908 Stieglitz changed the name to '291'. In spite of its limited proportions it was described by Marsden Hartley, one of the painters who exhibited there, as 'the largest small room of its kind in the world'.

Stieglitz was an intellectual and an aesthete of German Jewish descent, a photographer of unusual talent, a visionary and an enthusiast. His was a voice in the desert that made itself heard. Photography, he believed, should be recognized as an art and given serious consideration by all who had a genuine interest in painting, sculpture and all forms of visual experience. This did not in any way limit his appreciation of the older recognized forms of art and only served as a stimulus to his taste for new departures, including in particular those that were developing with such vigour in Paris.

To achieve his aim, he stressed the importance of using the most exacting standards of criticism and dedicated himself to the belief that first-rate camera work must be regarded as a fine art. With consistent courage throughout his life, 'he never ceased opposing the institutional, the academic, the unadventurous',[5] nor did he hesitate to show in his gallery a large range of *avant-garde* painters and sculptors, in order to place photographers on their level.

In this way, Stieglitz created a new source of inspiration. With the help of another remarkable photographer, Edward J. Steichen, who spent much of his time in Paris and was also a painter, he provided an astonishing series of exhibitions, bringing to New York for the first time the work of Rodin, Toulouse-Lautrec, the Douanier Rousseau, Cézanne, Matisse, Brancusi, Picasso and Picabia.

These well-timed appetizers of riches from abroad did not dampen Stieglitz's interest in American talent, which it was his ultimate purpose to encourage. There was therefore every reason, in 1911, for Man Ray to find his way to 291 Fifth Avenue. Daily during his lunch hour he would hurry there, fascinated both by what he found and by the long-winded enthusiasm of Stieglitz himself. The first exhibition which made a lasting impression on him was of Cézanne's water-colours. He was astonished that such slight indications in colour and such large expanses of white paper could create convincingly the appearance of space and form. He also enjoyed Rodin's sketches, with their free interpretations of figures in movement. These confirmed his belief that the freedom for which he was searching in his own drawing could bring far more effective results than the slavish copies made from casts in art classes. There was also a first exhibition of children's drawings to intrigue him, and a collection of African masks with their magic geometric patterns and Cubist forms, surprisingly placed beside the new 'gleaming, golden bronzes and smooth simple sculptures in wood or marble'[6] of Brancusi. Such revelations had for Man Ray an immediate appeal. Although they came from widely different sources, he could detect an inexplicable unity which pointed towards a new means of visual expression.

Another of Stieglitz's attractions was the quality and style of his own photographs, which were always, Man Ray tells us,

free of anecdote and cheap sentiment. They remained intensely figurative in contrast to the painting and sculpture he exhibited. I could not help thinking that since photography had liberated the modern painter from the drudgery of faithful representation, this field would become the exclusive one of photography, helping it to become an art in its own right.[7]

The implications of this realization became increasingly intriguing to Man as he came to understand that the visual

arts, set free and aided by photography, could find greater freedom of expression in the limitless world of the imagination.

Stieglitz noticed the frequent visits of this small slim young man who listened to him with deep concentration, his dark penetrating eyes set beneath eyebrows shaped like the wings of a raven missing nothing. Recognizing perhaps some distant affinity which could have originated in eastern Europe, a warm friendship began. Stieglitz asked to see some of Man's work and surprised him by inviting him to lunches with other painters at famous restaurants, such as the Holland House on Fifth Avenue, or the finest French restaurant in New York, Chez Mouquin. Although 291 was an expensive venture, there was no commercialism in the way it operated. Stieglitz continued to publish a *de luxe* photographic magazine, *Camera Work,* and applied himself to making his own photographs. Although he never made a portrait for money, he took photographs, when he was in the mood, of everyone who frequented the gallery, and he remained the centre of a large active circle of friends.

p. 25, I However, despite the fact that Stieglitz's attitude to photography coincided with his own, Man Ray did not abandon his deep desire to become a painter. What he saw at 291 gave him ideas for adopting new techniques, and in 1911 he produced a remarkable work, a tapestry composed of rectangular pieces of cloth which he had taken from a tailor's sheaf of samples. The effect is one of pleasing simplicity, and a discreet blending of colour makes it comparable to the monochromatic effects of the Cubist paintings that Braque and Picasso were making in a different climate that same year. The schematic arrangement of patches, lighter in tone in the centre of the design, suggests a dancing human form, but the tapestry owes its strength chiefly to its abstract qualities. It was a bold and successful experiment, which had at first a utilitarian rather than a commercial value, as a bedspread in the house Man Ray set up for himself in the country.

The life-class

In spite of this experiment in abstraction Man continued to work diligently from life, chiefly because he knew it was good training but also because of the new company, male and female, that it brought. By luck rather than design, he found a social centre uptown where he could join a night life-class. It happened to be a centre founded by a left-wing group of social workers in memory of Francisco Ferrer, the Spanish anarchist and idealist who had recently been executed in Barcelona, and it was financed by a successful New York writer. It provided classes in literature and philosophy as well as in art. 'All courses were free,' Man Ray tells us; 'Some well-known writers and painters volunteered their services as instructors; in fact, everything was free, even love.'[8] It was an atmosphere propitious in various ways for Man Ray's development. The young painters and sculptors were eager to discuss at length poetry and social problems, subjects outside the usual art-school routine. The instructors were recognized artists. One of them was George Bellows, already well known for the expressionist violence of his prize-fights and a pupil of the leader of a rebel group of artists, Robert Henri. Bellows immediately selected some drawings by Man as examples of the use of initiative and imagination. In addition to receiving such encouragement, Man found the models extremely attractive. His erotic impulses, which had formerly met with continual frustration, now began to find more gratifying encouragement, although his first adventure with a fellow student called Nancy came abruptly to an end with an icy tumble in the snow.

In his desire to lose no time, he made an attempt to organize his own Sunday life-classes, inviting three would-be artists and procuring the services of the most attractive model from the Ferrer Center. But again the plot ended in disaster. The class

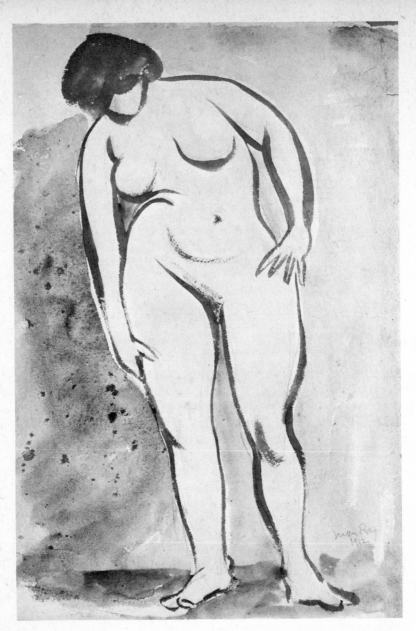

4 *Drawing* 1912

was held behind locked doors in his own home, and finding himself at such close quarters with naked beauty he became too excited, he says, to be able to concentrate on his work. He finally escorted the girl home, telling her all the way of the

1 *Tapestry* 1911

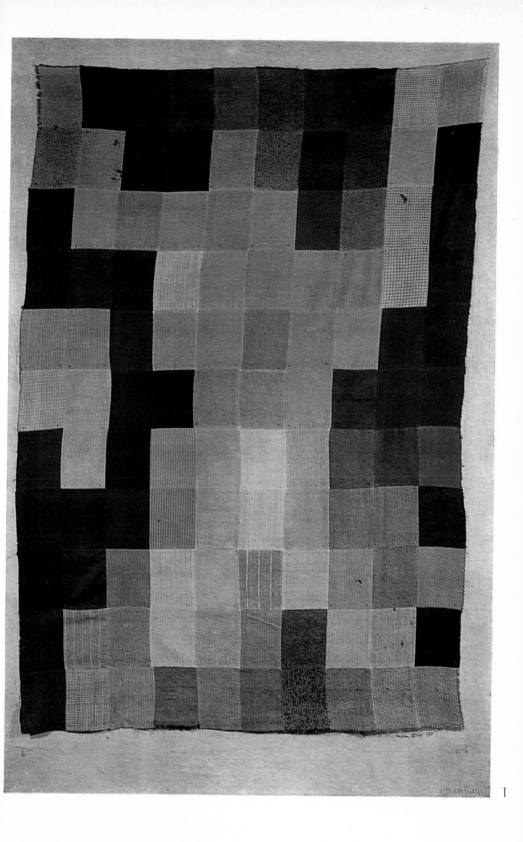

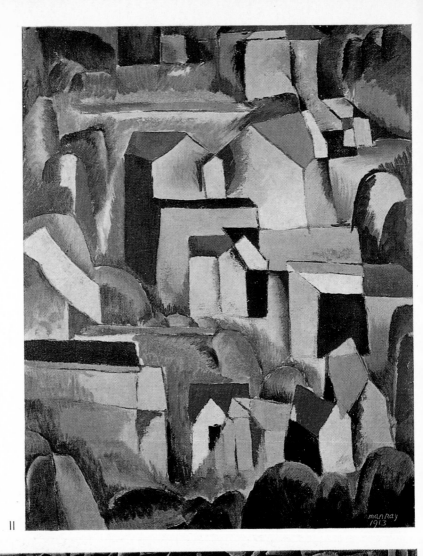

II

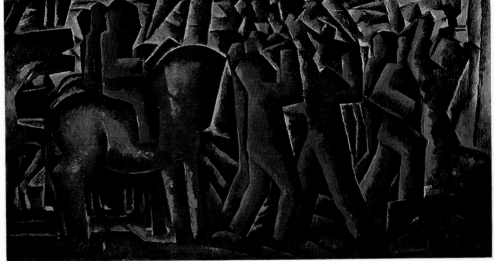

III

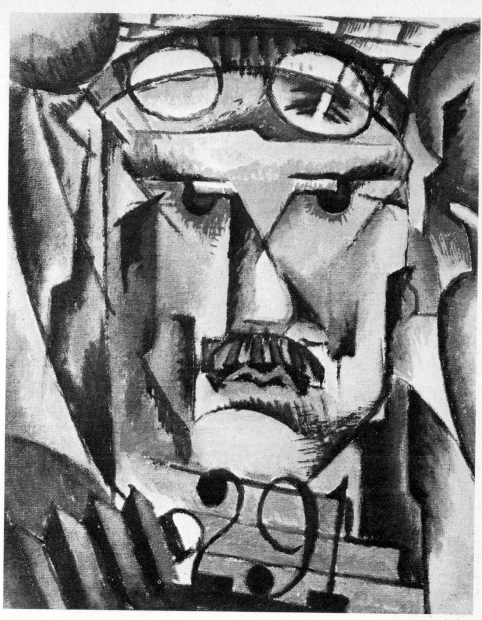

5 *Portrait of Stieglitz* 1913

irresistible power she had over him. As they parted she asked
him for a $50 fur coat, which he could not afford, and on
returning home he was severely reprimanded by his mother
when he confessed what had been going on in the family

II *Landscape (The Village)* 1913
III *AD MCMXIV* 1914

precincts. The project had to be abandoned, and he was reduced to making portraits of his young sister, a lovely girl with raven-black hair, who insisted on keeping his equilibrium intact by discreetly covering her other charms.

Portraits caused him less emotional disturbance and at an early age he showed a particular interest in faces, an interest which was to find its most admirable expression in the many photographic portraits he made in later years. He tells us that in his youth he dreamed of becoming a celebrated portrait-painter, and indeed there is a portrait of one of his friends, dated 1909, which shows remarkable ability as a character study and in which his youthful love of Frans Hals is evident; it is strong in its sense of form and subdued, almost classical, in its brushwork and colour. Another portrait, dated 1913, was painted in a more daring and original style. The sitter was Stieglitz, who by then was well acquainted with the young painter's work. Although the head is broken up into Cubist facets, it also presents a robust likeness to Man's friend. His glasses are pushed up on his forehead and the number 291 appears beside a camera in the foreground.

A return to nature

During one of his visits to the Ferrer Center, which he had begun to attend less regularly, Man met a painter, Samuel Halpert, who had just returned from Paris where he had been studying with Matisse. In spite of the intriguing attraction which anyone fresh from that city, even an older man such as Halpert, held for Man, their friendship took some time to mature, partly because Halpert was only interested in landscape and still-life, and partly because, on being introduced to Man's family, he fell in love with Man's sixteen-year-old sister, much to the annoyance of Man and his mother, who insisted that one artist in the family was more than enough.

By this time, Man Ray had realized that he must find a means of detaching himself from his home and settling where

he could work undisturbed. For a short period, for want of anything better, he shared a studio with Loupov, a sculptor whom he had met at the Ferrer Center. In the Spring he set out one morning with Halpert, to explore the Palisades Hills on the far side of the Hudson River. By chance they found at Ridgefield, in a lonely place, a group of houses near an orchard. They all belonged to an old Polish blacksmith who agreed to rent them the only vacant one, consisting of four rooms and a kitchen. Halpert agreed to share the rent, adding that he knew a writer who might take one of the rooms, and Man Ray returned home in great excitement. He had resolved to move away for good and install himself at Ridgefield, only returning to the city for the work he was obliged to do at the office.

The attractions of the city had begun to be wearisome. Man remembered the inner revolt against its 'conspicuous waste' that the poetry of Thoreau and Walt Whitman had inspired in him, and an intense desire to find the life of the woods and meadows stirred him to break with the artificial routines of city life. This refuge could bring him the peace of mind he needed and also, since it was reasonably accessible, could be compatible with the necessity of earning his living.

The plan worked well. He removed his easels, paints and canvases from Loupov's studio and managed eventually, after some protestation, to gain the co-operation of his mother, who even helped him with the essentials of bedding, chairs and a table. He found great satisfaction in being at last 'liberated from the restraints of civilization' and able to enjoy solitude in the exuberant atmosphere of Spring. Arriving before Halpert, he was alone to rediscover those delights which had been forfeited for so long and he set to work at once painting water-colours, which he pinned up around him to stake his claim to his room.

Although the main purpose of his flight from the city was to be able to concentrate on his painting, other ideas and

preoccupations filtered through. He was near enough to New York for frequent visitors to find their way to him; Halpert and his poet friend, Kreymborg, who soon arrived with a mandolin and a chess-set, brought the first diversions. More serious in its consequences, however, was the visit one Sunday of Loupov and half a dozen members of the Ferrer Center, including Manuel Komroff and Loupov's divorced wife Donna Lacroix a French girl with grey eyes and beautiful golden hair. Man had noticed her when she came to the life-class to fetch home an adorable child, her daughter, who had been posing for the students. The attraction on both sides was immediate and Donna, on Man's invitation, found no difficulty in abandoning the sordid surroundings in which she was living for the primitive comforts of the country enhanced by young love.

At Ridgefield, a period of idyllic happiness followed. The French girl, with her appetite for all that interested Man most passionately, was exactly the influence he needed both to enlarge his horizons and to satisfy the sexual urges which had tormented him until her arrival. She at once entrenched herself firmly in his heart, not only by her talent for cooking, but also by her interest in poetry. She had begun to write free verse and prose and it was through her that Man was first introduced to French poets such as Rimbaud, Mallarmé, Baudelaire and Apollinaire, and to Isidore Ducasse, the self-styled Comte de Lautréaumont and writer of turgid prose. All this brought an additional stimulus to painting. We see from an anecdote from the *Self Portrait* the flood of excitement and discovery that sprang from the fertile union between his work and his love.

One night that week [the first spent together] Donna retired early – she was not feeling well. Later when I came into our room with an oil lamp she was fast asleep. Her head on the pillow made an interesting composition; I decided to paint her. . . . The light was dim, but I knew my colours could adapt themselves to the circumstances. The painting was finished in an hour, and I bent over to kiss her. Unconsciously she put her arms around me. I went to bed. The next morning my first

thought on awaking was to look at the painting. It was a surprise: the face was a beautiful lemon-yellow. In the light of the oil lamp, I had mistaken the tube of yellow for white. However, I decided to leave it so; it looked as intentional as was the stylized drawing. Donna thought the painting very original.[9]

Chance had played into his hands with surprisingly happy results and this illusive element was in future to be watched for with a discerning eye like some rare and precious quarry. On seeing the peculiar originality of the portrait, his friends advised him to take it to Stieglitz. He also liked it and sent Man Ray to a well-known publisher, who at once bought the portrait for the modest but greatly appreciated sum of $150. The final outcome, an even greater surprise, came forty years later when Man Ray discovered that the painting had entered the collection of the Whitney Museum.

'My mind was in a turmoil,' writes Man of this memorable summer, 'the turmoil of a seed that has been planted in fertile ground, ready to break through.'[10] The little white and pink houses scattered among the trees over the distant hillsides inspired him to make many landscapes that have a freshness and an intensity eloquent of the sheer delight he felt. His work now became more personal. He had absorbed from his first impressions of Cézanne a sense of order in composition. The forms gained solidity and objective reality through an understanding of Cézanne's use of colour and his organization of distance without the use of conventional linear perspective. The landscapes showed also that Man Ray had begun to understand the motives behind the Analytical Cubism of Picasso and Braque, which he had seen for the first time in New York in the Spring of 1913.

The lovers were now settled contentedly in their country home. Donna became absorbed in writing short pieces of prose and poetry while Man, reducing the time he was obliged to

spend in New York, devoted himself more completely to painting. It was his aim to fill the resultant gap in their finances with an occasional sale. He suggested also that he should use his knowledge of typography and layout to produce a small *de luxe* edition of Donna's writings accompanied by his drawings. Man explains that although when translated into English, which was then his only language, Donna's writings seemed 'awkward at times, they were sincere and fresh like the paintings of naïve artists'. Stieglitz had had the courage to be the first to publish Gertrude Stein; Man Ray saw no reason why the publication of Donna's naïve work should not bring similar acclaim. When the book was finally completed, Man Ray designed the cover and made typographic compositions of the poems, the first of which was titled 'La Logique assassine'. He and Donna had it printed on the best paper available and they themselves bound all twenty copies, the entire edition. As winter set in, they began to enjoy even more their seclusion and each other's company, and the following Spring they submitted to convention by getting married.

6

The three-ring circus

By 1913, the interest and curiosity of those in America becoming aware of the revolutionary tendencies in the arts which were gaining ground in Europe blossomed into an event which left an indelible mark on the American scene and is remembered as a milestone in the growth of the appreciation of contemporary art. The newly formed Association of American Painters and Sculptors organized an exhibition in New York which became known as the 'Armory Show', because it was held in a disused regimental armoury on Lexington Avenue. The original aim of presenting only progressive American art was expanded by the organizers, and the show became an exhibition of international proportions, with most exhibits coming from France. Dorothy Norman wrote of it:

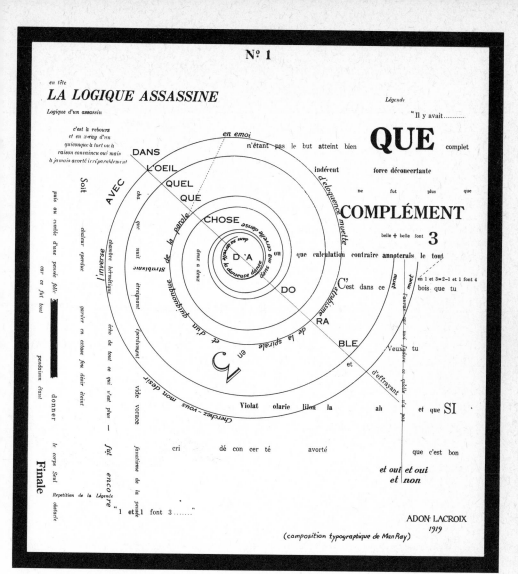

6 *Spiral Poem* 1919

The scope of the exhibition was indeed vast, tracing as it did the evolution of French painting from Ingres through Delacroix, Corot, Daumier and Courbet. It included works by Impressionists and Post-Impressionists, Expressionists, Cubists and Orphists, as well as painting and sculpture by numerous contemporary Americans.[11]

The first reaction of the Press, greatly excited by the scandal the exhibition was bound to cause, was to declare that the show

was a 'miracle', a 'bombshell', 'an event not to be missed'. But as the crowds of visitors increased, the bitter attacks of the critics began to spread dissent among those from whom the idea had originated, largely because the foreign element had stolen their thunder. Matisse and the Cubists were treated with scorn and the great painting *Nude Descending a Staircase* by Marcel Duchamp, an artist hitherto unknown in New York, became the symbol of madness and degeneracy.

Dedicated to a more intimate approach, Stieglitz had declined to play a part in selecting the works, but had accepted the role of Honorary Vice-President and announced in the *New York American,* before the opening, 'If you still belong to the respectable old first primer class in art, you will see there stranger things than you ever dreamed were on land or sea – you'll hear a battle cry of freedom without any soft pedal on it.'[12] His enthusiasm, however, was damped by what he called the 'three-ring circus atmosphere', quite unlike the still small voice of 291 where he had already exhibited many of the most vital artists involved. He was also disappointed by the inability of the organizers to give any continuity to this mammoth demonstration and he condemned the ephemeral excitement as 'having more to do with fashion or snobbism than with firm conviction'.[13]

For Man Ray, however, the Armory Show brought the eagerly awaited opportunity to see for himself the new life that was being infused into art in Paris. He had not yet produced any paintings that could make him eligible to take part in it, but it gave him new courage to tackle larger and more daring works and he was able to select those influences that meant most to him. As he tells us,

I had never worried about influences – there had been so many – every new painter whom I discovered was a source of inspiration and emulation. If there had been no predecessors, I might not have continued painting. Sufficient that I chose my influences – my masters.[14]

New friends

During the winter of 1913–14, in the calm of his retreat in the hills, Man Ray developed consistently the ideas which had been revitalized by the knowledge he had gained. Painting still-life and landscapes with more assurance, he started on larger canvases with compositions which reflect Cubist influences although, in contrast to the almost monochromatic Cubist paintings of Picasso and Braque he had seen in the Armory Show, they were 'very colourful'. One of his Ridge- p. 26, II field friends, Kreymborg, introduced him to a part-time poet named Hartpence who was working up the courage of a friend of his, Daniel, to open a gallery. They met in an old-fashioned beer saloon on Forty-Second Street and Ninth Avenue. Over beer and sandwiches Man Ray showed them a few small canvases he had brought with him. Daniel bought one for $20 on the spot and promised that, if his gallery materialized, when Man had enough paintings he would give him a show.

At times the isolation of the little house became complete, hemmed in by snowdrifts. But this did not upset the work or the happiness of the young couple. They worked with all the more concentration until Spring came and their friends began to return. Plans were hatched to found a Ridgefield artists' centre and publish books of poems and magazines, but such things had less lasting value than a visit, one day in summer, of two men who were in different ways to become important in the future career of Man Ray. Walter Conrad Arensberg was a man of great charm, with an acute sensibility for the arts in their most vital and varied forms. He had begun to collect contemporary paintings at the time of the Armory Show and, moving later in life to Hollywood, he gathered round him a great collection which is now in the Philadelphia Museum of Art. On this occasion he brought with him to Ridgefield the young Frenchman, Marcel Duchamp, who had recently become famous in New York by the scandal caused by

7 *Portrait of Donna* 1914

8 *Self-Portrait* 1914

his painting *Nude Descending a Staircase* during the Armory Show. The friendship that began that afternoon, initiated by an improvised game of tennis and in spite of their ignorance of each other's language, was of a rare quality, both fruitful and enduring. They understood each other's motives instinctively and remained conspirators together until 1968, when Duchamp died suddenly after dining with Man at his home near Paris.

Their first meeting took place in 1915. Duchamp had been excluded from military service in France and had come to New York to stay with the Arensbergs, well away from the war in Europe, from which America was still remote. When fighting broke out, in August 1914, Man Ray was finishing a large work inspired by the battles of Uccello. The painting showed men on the march and it only required the appropriate date to be inscribed on it in Roman numerals to give it its title and make it a picture of current events. This imposing work now hangs

p. 26, III

36

9 *Trees* 1914

in the Philadelphia Museum of Art. The influence of Cubism
is to be found in the angular shapes of the figures and the
shallow depth that limits the whole conception, but the forms
are unbroken and given some relief by shading, and colour
is used in a way that would not have been admitted in Analytical
Cubist painting. Several other large paintings of the same period
are in a romantic vein showing figures in a rural setting. The nude
female form melts into the background of rocks and trees with
subtle ambiguity. Examples of this period are *Five Figures* (1914),
now in the Whitney Museum, and *The Rug* of the same year. 10

May Ray, however, wished to go further to discover a style
which could give him satisfaction and for this the winter of
1914–15 seems to have been crucial. He recalls a conversation
with Halpert, while walking through the woods, when he
announced he was going to paint only imaginary landscapes in
future; 'Sitting in front of the subject might be a hindrance to

creative work,' he told his friend. The spell of the countryside had begun to wear off. 'Not only would I cease to look for inspiration in nature,' he continues, 'I would turn more and more to man-made sources. Since I was a part of nature – since I was nature itself – whatever subject-matter I chose, whatever fantasies and contradictions I might bring forth, I would still be functioning like nature in its infinite and unpredictable manifestations.'[15]

The following summer, 1915, these resolutions which had been forming in his mind gained strength from a new opportunity which suddenly appeared. The exhibition promised by Daniel in his new gallery materialized. There were difficulties with framing, which Man overcame by the simple but original idea of hanging muslin on the walls level with the pictures, thus giving the effect of frescoes painted directly on to the wall. In spite of the quality of the work and its ingenious presentation, the critics were extremely hostile and sarcastic. At the end of the show nothing had been sold. However, a few days later, Man received a telephone call in Ridgefield to say that Arthur J. Eddy, an elderly collector from Chicago and the author of a book on the Cubists and Post-Impressionists, was willing to buy six of the paintings for $2,000. Man Ray saw in this the chance to move back to New York for which he had been hoping secretly, and he accepted Eddy's offer without bargaining. Donna too was excited by the idea of returning to the city and the move soon took place.

Back to the smoke

The return to New York brought with it the exhilaration of being back in the throbbing heart of great activity. Man Ray found a studio on the fifth floor of an old brick building in Lexington Avenue, where pandemonium roared below in the construction of a subway. The contrast with Ridgefield was

10 *The Rug* 1914

11 *Totem* 1914

12 *Man Ray* 1914

immediately stimulating and was reflected in the unemotional precision of 'the pseudo-mechanistic forms' of a large composition which was the centre of his attention for some months. As usual the idea was not purely abstract. It originated in the movement of a tightrope-dancer and the shadows from the spotlights she cast around her. Having made many sketches and struggled with acrobatic forms in various positions for a long time, he saw that the shapes he had cut out of brightly-coloured paper as an aid could give him precise two-dimensional patterns, like those he had been using in a series of still-life

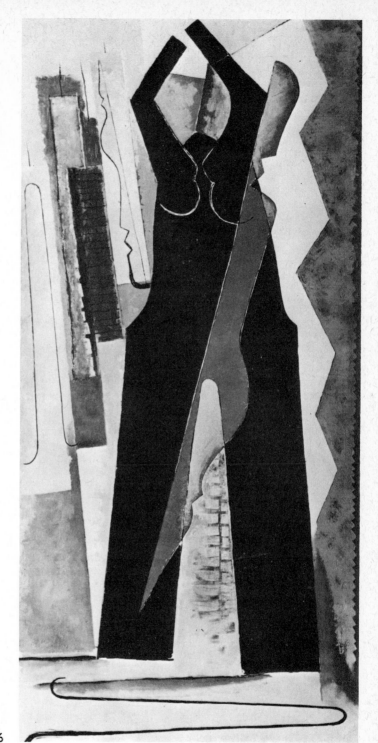

13 *Drawing* 1915

14 *Black Widow* 1916

p. 51, IV
p. 52, V paintings, *Arrangement of Forms*, but on a much larger scale. The dancer herself was transformed into a small star-like form at the top of the canvas, while her shadows filled the remaining area with bold architectural angular shapes in flat colour. 'No attempt was made to establish a colour harmony', he writes. 'It was red against blue, purple against yellow, green versus orange, with an effect of maximum contrast. The colour was laid on with precision, yet lavishly.' All this was done with deliberation. 'I was on the right track,' he continues; 'What to others was mystification, to me was simply mystery.'[16]

There were, however, a few who did appreciate the highly stylized 'flat manner' that Man Ray had invented, and he found himself invited to send a painting to an exhibition organized by a group forming round two painters, Macdonald Wright and Morgan Russell, who had started a movement before the war calling themselves Synchromists. These artists had worked with Matisse and had been noticed by Apollinaire as being vaguely linked to Orphic Cubism, a form of pure abstraction deriving its appeal from large geometric patterns of coloured surfaces. The painting sent in by Man Ray was a large canvas in his new flat manner, 'dominated by a black figure that could either be man or woman'. This work has now come to be known
14 as the *Black Widow* (1916) and is one of the finest examples of this period. It was much admired at the time by Stieglitz.

Excursions into the unknown

Early in 1916 Man Ray had his second exhibition at the Daniel Gallery. It was a small show centred round a strange panel
15 bearing the title *Self-Portrait*, which he describes thus:

On a background of black and aluminium paint I had attached two electric bells and a real push-button. In the middle, I had simply put my hand on the palette and transferred the paint imprint as a signature. Everyone who pushed the button was disappointed that the bell did not ring. . . . I was called a humorist, but it was far from my intention to be funny. I

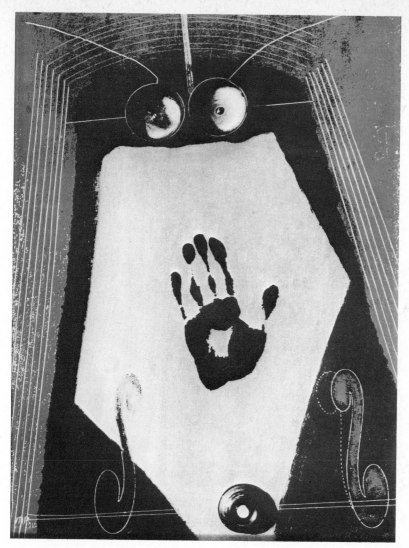

15 *Self-Portrait* 1916

simply wished the spectator to take an active part in the creation.[17]

The experiment nearly lost Man the patronage of the well-meaning but bewildered Mr Daniel.

This period was, however, one of great activity. It had begun with a series of large and highly successful canvases, such as *Promenade* (1915), *Dance* (1915), *Love Fingers* (1916), *Legend* 16, 17

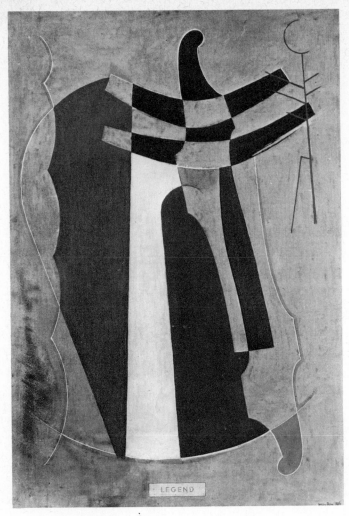

16 *Legend* 1916

p. 53, VI (1916) and *Symphony Orchestra* (1916), followed by those that I have already mentioned, giving Man Ray the stature of a brilliant and inventive young painter. Although all these paintings have now found their way to museums or distinguished collections, at the time they were painted the attention they received was in general hostile. It needed great fortitude for Man to weather, not only the continuous adverse criticism, but also the break-up of his marriage, which left him alone to struggle with his misfortunes and follow his purpose

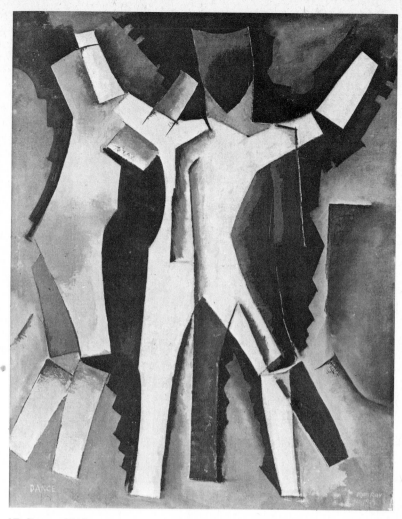

17 *Dance* 1915

with persistence. On looking back, however, he was able to write in his *Self Portrait:* 'I was filled with enthusiasm at every new turn my fancy took, and, my contrary spirit aiding, I planned new excursions into the unknown.'[18]

Realizing that painting could not provide him with an income that would keep him alive, Man continued to work a few days a week for his publisher, making mechanical drawings and using the techniques of the trade. In his efforts to find new methods which would liberate him totally from

18 *Theatr* 1916

the conventional manner of making pictures, and the aesthetic pretences that went with it, he hit on the idea of taking home with him the paint-spray he used for his office work and using it as a substitute for brushes and pencils. The airbrush outfit with pump and instruments at once gave unexpectedly pleasing results.

I worked in gouache on tinted and white cardboards – the results were astonishing – they had a photographic quality, although the subjects were anything but figurative. . . . It was thrilling to paint a picture, hardly touching the surface – a purely cerebral act, as it were.[19]

But in spite of the poetic motive underlying the airbrush pictures, and the freshness and originality of works such as 19, 20 *Suicide* and *The Rope Dancer* (both 1917), as well as *La Volière*, p. 54, VII, 21 *Admiration of the Orchestrelle for the Cinematograph, Seguidilla,*

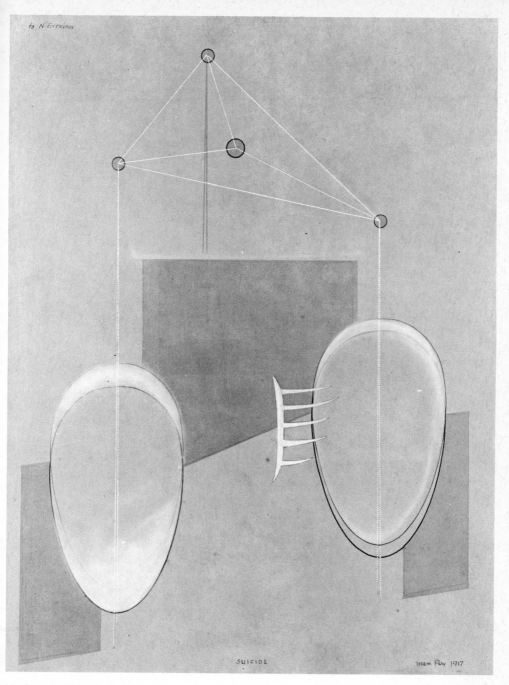

19 *Suicide* 1917

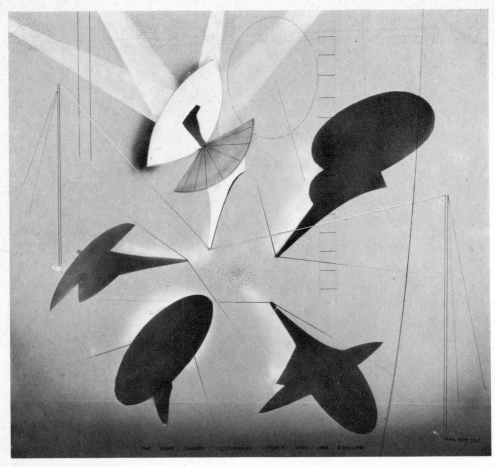

20 *The Rope-Dancer Accompanies Herself With Her Shadows* 1917 (aerograph)

22, 23, 24 *Jazz* and *Hermaphrodite* (all 1919), they, just like the rest of his work, met with a hostile reception.

There were indeed moments when Man felt his high spirits severely undermined. This had happened particularly during moments of emotional stress when the excitement of the return to New York had begun to wear thin and his marriage was disintegrating. One of the first airbrush paintings is a witness to the reality of his state of despair. After being labelled a degenerate, a charlatan and a criminal for having destroyed the

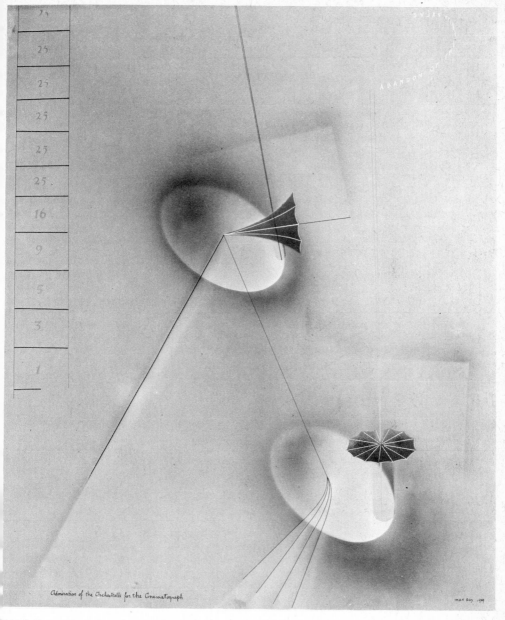

Admiration of the Orchestrelle for the Cinematograph

21 *Admiration of the Orchestrelle for the Cinematograph* 1919

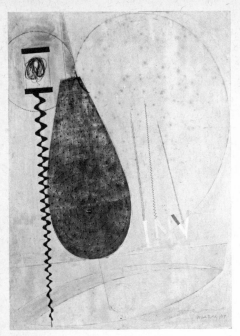

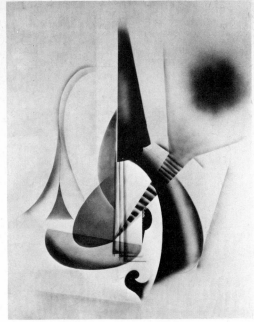

22 *Involute* 1917 23 *Jazz* 1919

art of painting by using mechanical means, Man Ray made a picture with his newly discovered technique. Having written on it its title, *Suicide*, he placed it on an easel with a loaded gun pointing at its centre. His plan was to stand behind the picture and fire off the gun by means of a string, but on second thoughts he realized that he could then be accused of assassinating by mechanical means not only art but also himself. Influenced also, he said later, by 'the thought that my suicide might give pleasure to some people', he gave up the idea. Later, in Paris, the picture was reproduced as Man Ray's contribution to an inquiry being made by André Breton in *La Révolution surréaliste,* the subject of which was, 'Is Suicide a Solution?'

A third exhibition was held at the Daniel Gallery in 1919. This time it was the aerographs, of which there were ten, that mystified the public. Bewildered visitors kept asking Man Ray for a solution, but he answered enigmatically that he always began with the solution and there could therefore be no problem.

 IV *Arrangement of Forms, No. I* 1915

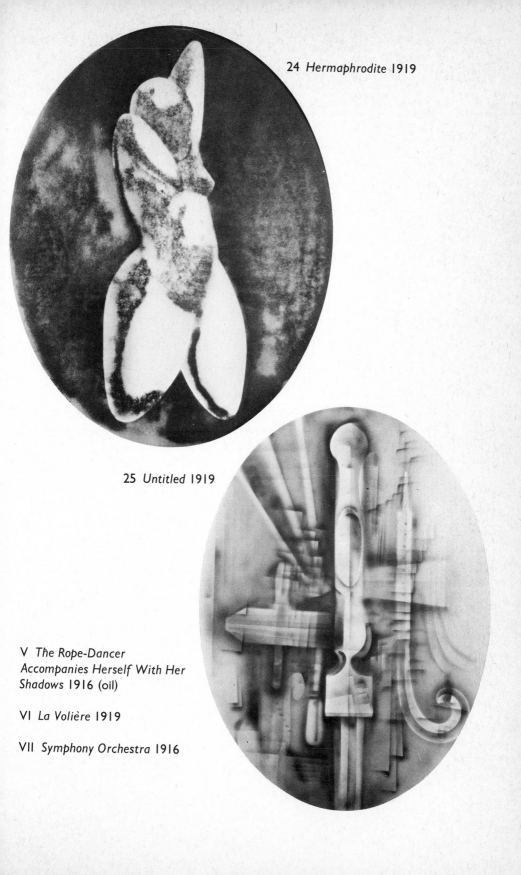

24 *Hermaphrodite* 1919

25 *Untitled* 1919

V *The Rope-Dancer Accompanies Herself With Her Shadows* 1916 (oil)

VI *La Volière* 1919

VII *Symphony Orchestra* 1916

pp. 79, VIII, 80, IX The exhibition was crowded throughout, but again nothing was sold. One of the main exhibits, placed in the centre of the gallery and radiating from a central pillar, was a series of ten collage compositions made in 1916–17, the *Revolving Doors*. They appeared as a new and startling contribution to *avant-garde* art. The simple interlocking shapes were conceived in flat colour based on the three primaries, red, blue and yellow. Far from being abstract conceptions, the compositions had their origin in objects which had attracted Man Ray's attention and which he had reduced to simple geometric forms. Taking sheets of brightly coloured paper intended for scientific diagrams, he cut out the shapes and pasted them with care on to sheets of white cardboard, allowing them to overlap in order to obtain the depth of transparencies. A third dimension was created by the fact that bright colours, when juxtaposed, refuse to lie visually in the same plane. In Man Ray's words: 'The inevitable result is a projection into space: an equivalent of light.'

More than twenty years later, when he was in Los Angeles, Man Ray discovered that the coloured papers were fading; with great care he made from them a new set, this time considerably larger and in oil paint on canvas. In the preface of a recent publication containing a set of very accurate reproductions of the *Revolving Doors*, I wrote:

The compositions which might ignorantly be mistaken for abstract patterns were the product of poetry and humour. Titles attached themselves to them, which in turn gave a new imaginary dimension, with echoes that lead beyond their visual appearance. To the titles, Man Ray added short observations intended to enlighten or bewilder. When he was asked to recite them for a film made by Hans Richter, he ended with an enigmatic 'Ha, ha, ha, ha!' to prove that in his belief the truest sense is often nonsense. The paragraph for Plate X, *Dragonfly*, finishes: 'If the creature had consulted its will only, it was bound to be crushed against the unknown.'[20]

Marcel Duchamp

Ever since their first encounter at Ridgefield, there had been a constant flow of inventions, puns, absurdities and commonplace necessities exchanged by Man Ray and Marcel Duchamp. When Man returned to New York, Duchamp was already installed in a studio at 1947 Broadway and had begun work on his *Large Glass (The Bride Stripped Bare By Her Bachelors, Even)* with untiring concentration. Though Man had seen his painting in the Armory Show, what fascinated him was not Duchamp the painter but rather Duchamp the rebel, the iconoclast, the inventor of the Readymade, the mocking admirer of the machine wherein he found innumerable resemblances to our own actions and sexual habits.

With the fame brought by the scandal of *Nude Descending a Staircase* behind him, Duchamp surprised everyone by abandoning painting and adopting an attitude towards art which coincided with Man Ray's ideas. Duchamp's first published statement, in a New York art review, was entitled: 'A Complete Reversal of Art Opinions by Marcel Duchamp, Iconoclast'. His ability to select commonplace objects so as to set the focus on them rather than on aesthetic interpretations opened up a new sphere – a region in which the fertile wit of Man Ray was to flourish and in which there began to appear an astonishing variety of objects given new meaning.

There was a lingering reference to sculpture in early experiments by Man Ray such as *New York I* (1917), which consisted 26 of no more than flat wooden laths cut into various lengths, held together in an iron clamp and placed on a shallow circular base so that they point upwards, and also two other wood objects, *By Itself I* and *By Itself II* (1918). As time passed, 27, 28 however, the sculptural reference became less emphasized. America, isolated from Europe by the war, was witnessing the birth of the 'crise de l'objet', of which André Breton wrote with eloquence some twenty years later.[21] New York became

conscious of this new departure in dramatic fashion when Duchamp's incognito contribution to an exhibition organized by the Society of Independent Artists, of which he was a founder member, was rejected. Duchamp at once resigned. His contribution had been a Readymade, *Fountain,* a common porcelain urinal signed 'R. Mutt'.

Duchamp and Man Ray remained in close contact. A place where they were sure to meet was the chess club, a centre for chess addicts and intelligent players of all ages and sexes. From there, they would wander through the streets late at night, sometimes returning together to one of their studios. Their intimacy increased when Man's troubles with Donna were most acute and his painting was least acceptable to the public.

For some time, Man Ray had been using a camera to make photographs of his own work. He next began to take pictures of his friends, an activity in which his talent for portraiture found new scope. The use of photography as an adjunct to the tools at the artist's disposal was appreciated by Duchamp, and one famous photograph was taken by Man Ray in Duchamp's studio in 1920. Under the dim light of the single lamp, Man left the shutter of his camera open for an hour and succeeded in obtaining unexpected effects. The photograph appears to be a landscape, partly covered by drifting cloud, and seen from the air; in reality, it is a close-up view of part of the *Large Glass* on which Duchamp was laboriously working. The dust and cotton waste which covered the glass explain the title of the photograph, 30 *Elevage de poussière (Dust Farm).*

But in photography the inventive genius of Man Ray went beyond the use of the camera. Any conceivable way of employing photographic processes to bring surprises was legitimate. In 1917 he revived the *cliché-verre,* a process used formerly by the Barbizon School, in which a drawing is made on a glass negative with a needle-point and is then printed on sensitized paper; in later years, his Rayographs and solarizations added new scope to the photographer's art. In the early days

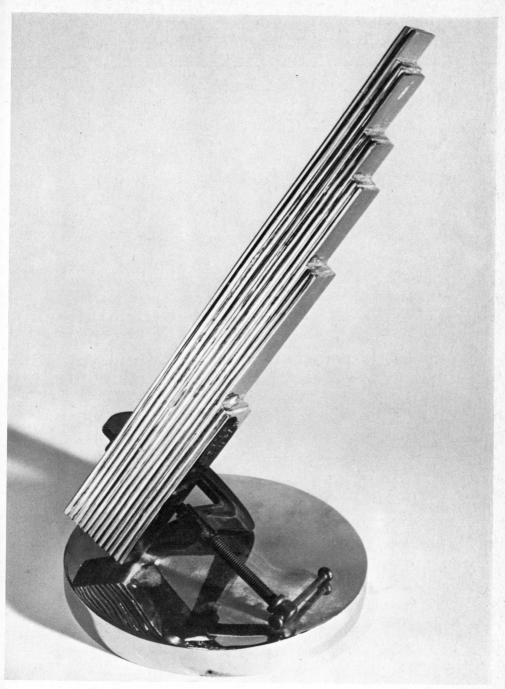

26 *New York I 1917/66*

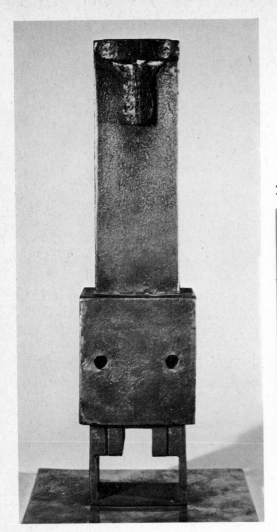

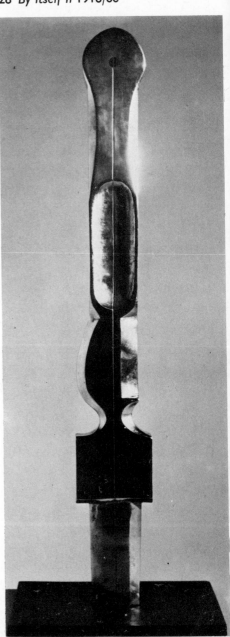

28 By Itself II 1918/66

27 By Itself I 1918/66

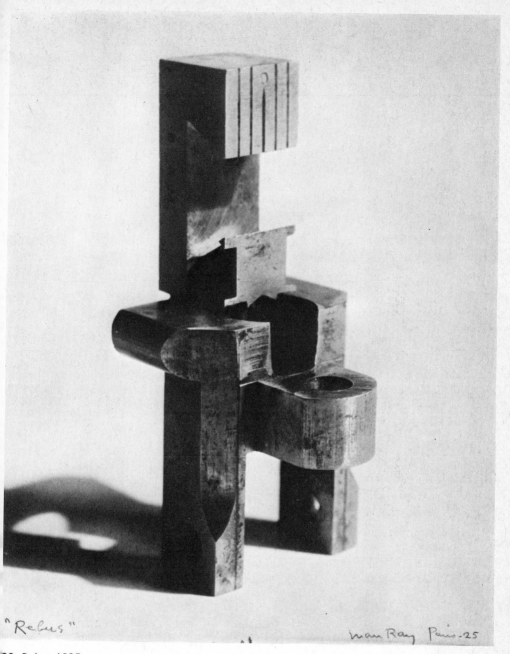

"Rebus"

Man Ray Paris-25

29 Rebus 1925

3/10

in New York, Duchamp had asked for Man Ray's help in an invention he hoped to perfect for making three-dimensional movies, but after ingenious contrivances had been laboriously tried out and kilometres of film consumed, with only a glimmer of success, they abandoned the project as being too complicated and too costly.

The first modern museum

Another and more successful enterprise was launched: Duchamp informed Man that he was to become vice-president of a new centre for the arts. A New York lady, Katherine S. Dreier, had told him that she wished to convert her brownstone house in Fifth Avenue into a museum and a meeting-place for artists. She needed the help of Duchamp and Man Ray in choosing the works and in forming a policy for aims and

30 *Elevage de poussière* 1920

31 Man Ray in New York 1919

activities. She also wanted Duchamp, with Man Ray's help, to see to the redecoration of the interior, and she realized that Man could be of great assistance as lighting expert, official photographer and public relations officer. The first necessity was to find a name for the project. With naïve pertinency, Man Ray suggested that the centre should be called 'Societé Anonyme', which to him in his ignorance of French meant only 'Anonymous Society', without any legal or commercial signification. The title was adopted unanimously.

The year 1920 saw the opening of the Societé Anonyme, the first modern museum in America. Its elegant white walls were covered with shiny oilcloth and lit by blue daylight bulbs. It attracted painters such as Joseph Stella, and gradually introduced a distinguished list of artists from abroad, including Kandinsky, Klee, Léger, Villon, Schwitters, Ernst, Miró, Mondrian and Malevitch. One of the first of its sponsored

lectures was given by Man Ray, who held the audience in a spell from which they were finally and abruptly released by a more matter-of-fact discourse from Katherine Dreier. There was also a symposium on Dada, and translations of Apollinaire were made available.

In Europe, Dada had come to life in Zürich in much the same mood as that in which Man Ray, with Duchamp as his companion, had found himself immersed in New York. The two conspirators were supported also by the friendship of Edgar Varèse, the musician, and by the brief but turbulent presence of both Francis Picabia and Arthur Cravan. Independently, they had started to move in the same direction as the Dada groups in Zürich, Cologne and Berlin, and it was natural that, as soon as the war finished, close links should be established between those whose attitude to war, art and the establishment were so close. Duchamp was soon in correspondence with Tristan Tzara, a founder of the movement in Zürich. Tzara sent him a mock authorization for the publication in New York of a Dada magazine. To this Man Ray gave his assistance and obtained contributions, mostly unsigned, from Marsden Hartley, Stieglitz and several others. But only one number appeared and Man noted sadly, 'The effort was as futile as trying to grow lilies in a desert.'

An overwhelming feeling of restlessness had been growing in Man Ray when Duchamp, who had already made a trip to the Argentine, announced his intention of returning to Paris and encouraged his friend to follow him. Man Ray had no doubt that he would be glad to do so, but the money was lacking. By that time, he had had considerable success with portrait photographs. Many friends, including Myrna Loy, Djuna Barnes and Elsa Schiaparelli, had been delighted with the results and with the generous way in which they were treated, but the income from this was still too small to pay for a transatlantic crossing and also cover the risks involved in

beginning a new life in a foreign country. On the advice of Stieglitz, Man wrote to a retired coal tycoon from Toledo, Ohio, who had already bought a few of his works from Daniel, offering him several paintings on condition that he would be willing to finance the trip to Paris. The result was most gratifying. Mr Howald provided him with a cheque which could be repaid with paintings when they met again in Paris, and Man Ray left New York in high spirits. However, he tells us that when his benefactor saw his work in Paris a year later, he disapproved of it categorically, telling Man Ray that a painter should stick to painting and that it was also wrong for him to have become an expatriate.

2 Paris 1921–1940

Paris and poets

By chance, Man Ray found himself in Paris on 14 July 1921. The national fête commemorating the storming of the Bastille was in full swing and Marcel Duchamp was waiting for him at the station. His friend had found a hotel for him in Passy, a respectable part of the city, where a few days before Tristan Tzara had been staying, attracted to Paris for the same reasons as Man. The city's magnetism was drawing to it Dada revolutionaries from distant regions; Tzara and Arp had come from Zürich, Max Ernst from Cologne, Picabia, Duchamp and now Man Ray from New York.

The hotel sign announced modestly 'Hôtel Meublé', which to Man seemed sufficiently distinctive until he discovered there were hundreds more with the same sign, and that their speciality was to provide a rendezvous for lovers. However, as soon as he was installed Duchamp took him to a place in the centre of Paris which was of unique interest. The Café Certâ, hidden in one of the old Parisian arcades, Le Passage de l'Opéra, had recently become the meeting-place of a small active group of young men who were to be of great importance to Man Ray throughout his life. The café had been chosen for its seclusion and for the excellence of its many varieties of port and English ale. It reflected an atmosphere of clandestine familiarity among its clients which could have been intimidating to any young foreigner arriving in Paris for the first time with no knowledge of the language. As he entered, Man Ray found himself surrounded by a group of brilliant, argumentative and highly critical intellectuals. But as Duchamp introduced him with conventional handshaking and formal French politeness,

32 *Self-Portrait* 1933

the young American, with his jet-black hair and curly forelock, his large dark eyes eager, his head slightly lowered like a small bull ready for the attack, was in no way embarrassed. This was, in fact, precisely the surprise he had hoped for. He tells us that he

felt at ease with these strangers, who seemed to accept me as one of themselves, due, no doubt, to my reputed sympathies and the knowledge they already had of my activities in New York. André Breton, who was to found the Surrealist movement several years later, already seemed to dominate the group, carrying his imposing head like a chip on the shoulder. Louis Aragon, writer and poet, also bore himself with assurance and a certain arrogance. Paul Eluard, the poet, with his large forehead, looked like a younger version of the portrait of Baudelaire I had seen in a book. His wife, Gala, a quiet young woman, who ten years later became the wife of Salvador Dali, spoke some English and I encouraged her in order to make conversation. The young medical student Fraenkel, with his slanted eyes and high cheek bones, looked impassively oriental. Philippe Soupault, poet, like an impish schoolboy with his twinkling eyes and curly hair, seemed ready for some mischief. Rigaut was the handsomest, the best dressed of the group – my idea of a French dandy, though his lips had rather a bitter twist. . . . Curiously enough, at the time of my first encounter there were no painters in the group.[22]

One of the characteristics of the group was in fact the close and fruitful association of poets and painters.

The Café Certâ has been brilliantly described in detail by the 'arrogant' Louis Aragon in *Le Paysan de Paris*. Giving an intimate picture of this typically Parisian haunt, he says of the gatherings of his friends: 'It is this place that was the principal seat of the sessions of Dada, where that formidable association plotted some of its trivial and legendary manifestations which caused its grandeur and its decay.'[23] Understandably, Man Ray's comment on this unforgettable confrontation was that he felt he 'had been catapulted into a new world'.[24] Even so, the new world was an echo or rather the origin of the same revolt he had helped to initiate in New York, in the company of Duchamp and Picabia. The desire for anarchy and the

destruction of all former values was shared even more acutely by those who had been closer to the misery of a society intent on self-destruction. At the time of Man Ray's arrival in Paris, however, the thoughts of this turbulent group were beginning to shift from an implacable wish to destroy conventional standards towards a more constructive attitude. As Dada lost its initial motivation, Man Ray was able, again by chance, to assist in the creation of a new *avant-garde* movement, Surrealism. A major event in his voyage of discovery had taken place within a few hours of his arrival from New York. He had at once joined this group with which he was to remain closely associated and of which Patrick Waldberg has written: 'It was thanks largely to these young men that Paris could still be qualified for nearly the next twenty years as Balzac's "monstrous marvel . . . the head of the world".'[25]

With an ardent desire to explore Paris in every sense and every direction and to learn French, Man Ray set out, usually on foot to save his meagre resources. His flair for noticing those things usually passed over by others helped him rapidly to discover the mysteries and to adapt himself to the banalities of the life of a city that at once enchanted him. It was in fact the way of living that interested him, rather than the great monuments. He tells us that he became so preoccupied with this city in which 'even the most sordid quarters seemed picturesque', as well as with his own work and the activities of the Dadaists and Surrealists, that it was only after ten years in Paris that he at last 'wandered into the Louvre for an hour'.[26]

The process of making new friendships was, in contrast, surprisingly rapid. Moving first to Duchamp's small flat which was empty during its owner's absence, Man soon found his way to Montparnasse, a quarter which had attracted artists of all nationalities for some years and where small hotels and studios were abundant, providing the basis of an inexpensive life of freedom. The existence of many cafés, large and small, made

possible frequent chance encounters, with friends, enemies and strangers, which were all part of daily life. Having taken a room in a hotel in the centre of this quarter, Man Ray improvised for himself a dark-room for his photography in the bathroom, and found enough space to store the work he had brought with him from New York. He also managed to continue drawing and painting in a restricted way and surprises came frequently. 'One day', Man Ray tells us, 'Breton, Eluard and Aragon came to see my paintings; Soupault was planning to open a gallery and I could have the first show.'[27]

The enthusiasm aroused by Man Ray's work became evident when, within a few months of his arrival, his friends organized the exhibition of his work at the Librairie Six; they printed a catalogue with the heading 'Good News', followed by a biographical sketch, compiled with typical Dadaist humour, which claimed that, though no one knew where he had been born, after a career as a coal-merchant Man Ray had become a multi-millionaire and chairman of a chewing-gum trust. Some thirty works, dating from 1914 onwards, were shown in the exhibition, and eulogies in the catalogue were signed by Aragon, Eluard, Max Ernst, Ribemont-Dessaignes, Soupault and Tzara, who concluded:

New York sends us one of its love fingers [the title of one of the paintings] which will not be long in tickling the susceptibilities of French painters. Let us hope that this titillation will again indicate the already well-known wound which marks the closed somnolence of art. The paintings of Man Ray are made of basil, of mace, of a pinch of pepper, and parsley in the form of hard-souled branches.[28]

Man Ray was welcomed by the Dadaists as a new defiant influence and a 'pretext for the group to manifest its antagonism to the established order'.[29] The opening of the exhibition attracted even those like Picabia who had already seceded from the movement. But the most significant visit was from the musician Erik Satie, 'a strange voluble little man in his fifties . . .

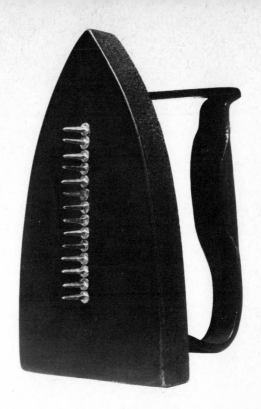

33 *Cadeau* 1921/63

with a little white beard, an old-fashioned pince-nez, black
bowler hat, black overcoat and umbrella, he looked like an
undertaker or an employee of some conservative bank'.[30] His
immediate response, made intelligible by his fluent English,
warmed Man Ray's heart and stimulated him to improvise a gift
for Satie which he called *Cadeau* and added at once to the show: 33
in a shop near by, he bought an ordinary flat-iron and added
down its centre a row of tin-tacks glued to the surface, making
an absurdity of the iron's avowed purpose. By this simple
adjustment, the flat-iron had forfeited its former identity and
become a symbol of nonsense and inutility, a classical example
of the disturbing effect provoked by all such creations of Man
Ray. We are delighted by the sly humour and perplexed by the
radical change in identity that has been produced by such
slight means.

In spite of the crowded opening and the enthusiasm of Man's
friends, as usual, when the exhibition closed, nothing had been

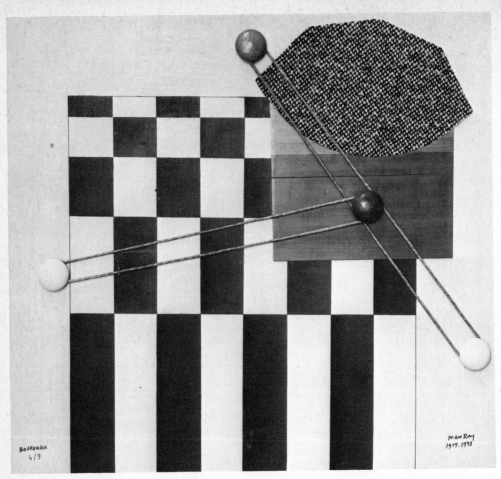

34 Boardwalk 1917/73

sold. Even the set of *Revolving Doors*, left with a well-known dealer, had failed to find a buyer, and Man Ray became seriously worried about his future. Before changing course in such threatening weather, however, he made a last attempt to break through the prejudices of the cliquish Parisian art establishment. He sent two of his most original works, *Catherine Barometer* and *Boardwalk*, to the Salon des Indépendants, where anyone could exhibit, but again they were either ignored or dismissed as Dada sensationalism. It took forty years for these two works to be accepted as works of outstanding importance, prophetic of present tendencies in the arts.

34

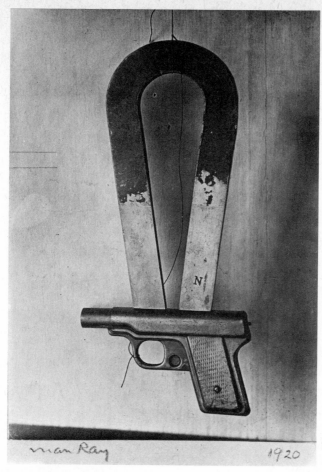

35 *Compass* 1920

The image of light

Fortunately Man Ray had another source of making a living: photography. He had originally despised the idea of taking photographs of the paintings of other artists but, encouraged by Picabia, who offered him an opportunity in this direction, he reconciled himself to hackwork. This crisis proved to be a turning-point and the solution, once accepted as inevitable by Man Ray, brought with it considerable advantages, such as the liberty to frequent his new friends without embarrassment and to divorce his painting from the necessity of making it saleable.

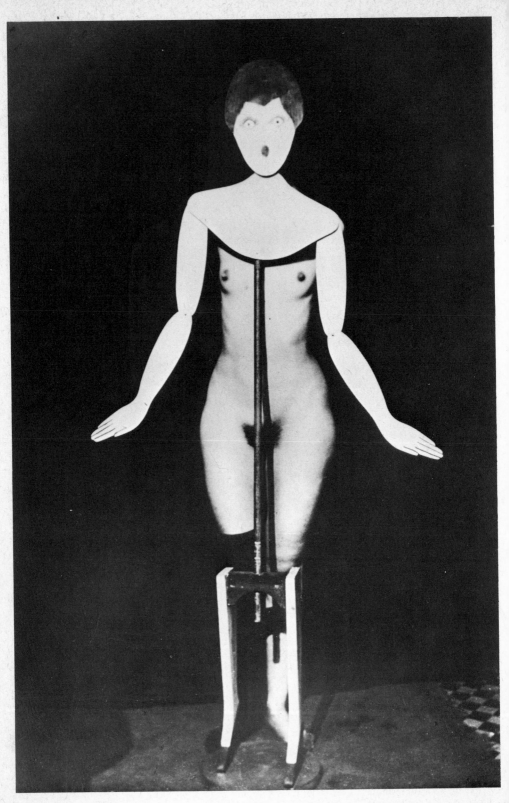

36 *Coatstand* 1920

37 *Transatlantic* 1920

Also, it gave him the opportunity to make new discoveries in the art of photography which were soon to earn him fame, in spite of his aversion to becoming primarily a photographer.

It was the attitude that Man Ray had evolved towards the whole process of photography which permitted an alliance between his talent as a painter and technical processes. Any method he could devise might be used as a means of poetic expression. The original invention of a surface prepared with silver nitrate which is highly sensitive to light offered incalculable possibilities in the sphere of visual poetry, as well as in science and commerce. The idea of capturing light itself on a

sensitive surface, rather than imitating the illumination it gives to objects around us, brought about a revolution of great importance, irrespective of the problem of colour which was to be tackled only at a later date. Since Man Ray is essentially a poet, the division between painting and photography becomes imperceptible in his hands. He has, moreover, been able to argue that he uses photography for those things he does not wish to paint and painting for what cannot be photographed.

I have already mentioned the unusual talent Man Ray possesses for portraiture, which is evident in the portraits he made when he was nineteen. The camera was now to take over from brush and palette, and with his sensitivity for his sitter the results, about which I shall have more to say later, were astonishing. While recognizing this talent, the *avant-garde* poets found other reasons for being increasingly intrigued by his work. Man tells us how chance once more presented him with a new discovery. He worked late into the night in his improvised dark-room, developing the plates he had exposed during the day, and making contact prints on sheets of paper spread out under the glass negative on a table lit by an electric bulb hanging from the ceiling. It was this primitive set-up that made possible a startling development in photography, when he inadvertently placed a few objects on a sensitized sheet under the light. To his surprise, an image grew before his eyes on the paper under the light, 'not quite a simple silhouette of the objects, as in a straight photograph, but distorted and refracted by the glass more or less in contact with the paper and standing out against a black background, the part directly exposed to the light'.[31] It was the same idea he had used as a boy, when he placed fern leaves in a printing-frame and obtained a white negative print of their shadows, but with an additional three-dimensional quality and with tone gradation. 'Taking whatever objects came to hand,' he tells us, 'my hotel room key, a handkerchief, some pencils, a brush, a candle, a piece of twine . . . I made a few more prints, excitedly, enjoying myself immensely.'[32]

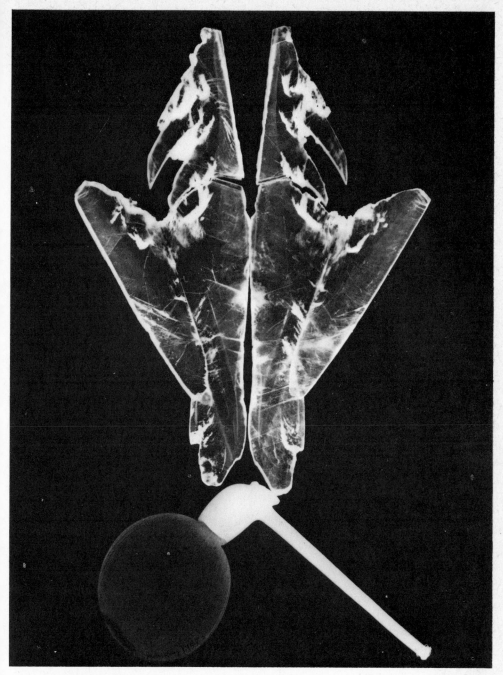

38 *Bubble Emerging from Clay Pipe, and Frosted Leaf* 1947

39 *Circular Objects in Motion, with Tacks, Spring and Electric Plug* 1922

VIII *Orchestra* 1916–17/42

40 *Kiki Drinking* 1922

41 Rayograph

42 Rayograph

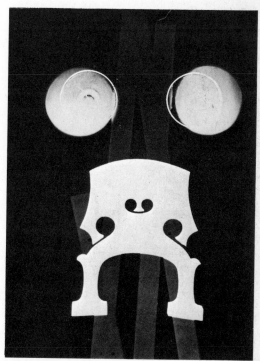

IX *Mime* 1916–17/42

This excitement at his invention of the Rayograph, as he decided to call it, was shared by Tzara, who had taken a room in the same hotel. On seeing the prints, he was at once very enthusiastic and claimed that they were 'pure Dada'. Man Ray tells us, 'Tzara came to my room that night; we made some Rayographs together, he disposing matches on the paper, breaking up the matchbox itself for an object, and burning holes with a cigarette in a piece of paper, while I made cones and triangles and wire spirals, all of which produced astonishing results.'[33]

Tzara, carried away by the new possiblities, wanted to go further with other materials, but the inventor cautiously called a halt. 'I felt', he explains, 'somewhat jealous of my discovery and did not care to be influenced by his ideas.'[34] This, however, did not diminish the enthusiasm of Tzara, and soon after, when Man Ray produced an album, *Les Champs délicieux*, Tzara gave it a lively preface. He foresaw, however, what might have been in aesthetic terms a vulnerable insufficiency when he wrote, 'But, says you, colour is lacking as well as the trembling of the brush.' To this, Man Ray added forty years later in an amplified portfolio of Rayographs exhibited in Stuttgart:

Like the undisturbed ashes of an object consumed by flames, these images are oxidized residues, fixed by light and chemical elements, of an experience, an adventure, not an experiment. They are the result of curiosity, inspiration, and these works do not pretend to convey any information.[35]

'Is Dadadead? Is Dadalive?'

Although he had chosen to live in Montparnasse, a quarter not wholly approved of by Breton and his more rigorous companions because of its reputation for promiscuity and doubtful connections, Man Ray kept closely in contact with all those who interested him, despite their differences of opinion and the violent arguments which broke out frequently between them.

The major cause of dispute was the waning influence of Dada and the rise of Surrealism. Tzara, always on the attack in spite of being on the losing side, organized in July 1923 a Dada manifestation, to which he gave the title 'Soirée du cœur à barbe'. Man Ray, whose loyalties to either side were not involved, at once offered his support, little realizing that it was to be the cause of the final split between Tzara and Breton.

It seemed probable that the evening of 6 July would end in violence since, although Picabia had deserted the movement of his own accord, Breton was under attack from the majority of his friends for an abortive attempt to organize a grandiose 'Congrès de Paris', which was to have studied the whole position of Dada. According to Tzara, however, its purpose was merely to decide 'whether a railway-engine was more modern than a top hat'.

Without warning, the day before the performance was due to take place at the Théâtre Saint-Michel, Tzara asked Man Ray to produce a film. When the latter protested, Tzara insisted that he should use a process similar to the Rayographs, an idea that stirred Man Ray's imagination and set him to work. With small means but great ingenuity, he succeeded in putting together enough film to last for about three minutes, using the shadows of pins, tin-tacks, salt and pepper sprinkled lightly along the length of the film without dividing it into frames. To this he added a few haphazard shots made with a camera. He was satisfied that, anyhow, it would be all over before the audience had time to react. Unfortunately, owing to the inexpert haste with which it had been stuck together, the film broke, plunging an exasperated audience into darkness. Man had called the film *The Return to Reason*, but it produced in the spectators, thoroughly in keeping with Dada traditions, a wild outbreak of shouting and fisticuffs in the stalls. This was intensified by Breton's ferocious assault on the actors who had appeared on the stage, and ended in complete pandemonium with the entrance of the police.

The evening ended the Dada movement by bringing about the final break-up of Breton and Tzara; to Man, however, it brought new prestige, partly perhaps because no one saw *The Return to Reason* to its end, but also because of the intriguing effects he had achieved in the film. The images

looked like a snowstorm, with the flakes flying in all directions instead of falling, then suddenly becoming a field of daisies as if the snow had crystallized into flowers. This was followed by another sequence of huge white pins, crisscrossing and revolving in an epileptic dance, then again by a lone thumb-tack making desperate efforts to leave the screen.[36]

Man, however, did not follow up this provocative though indecisive success. He realized that he would be expecting too much of the film industry and the public if he pursued his real inclinations. Even so, he recognized that movies were a part of the art of photography offering endless possibilities. When the opportunity came to help Duchamp film spirals in motion on an inverted bicycle in the garden of Marcel's brother, Jacques Villon, Man was delighted to join them.

In their unique position, deeply involved in art and yet detached from partisan disputes, Man Ray and Duchamp were respected and honoured by all. Even Breton, who could be extremely intolerant, never reproached either of them for their refusal to become involved in politics, nor did he object to Man Ray's growing association with the mundane world of fashion.

Portraits

Before turning his attention again to films, Man Ray found other and more profitable uses for photography, to which he now gave the greater part of his time. His reputation for making portraits had grown rapidly. This activity, which began as a sideline, had an added interest in that it involved him with painters, poets, sculptors and musicians of great distinction;

evidence of this can be found in the album published in 1934, which offers us one of the most splendid portrait galleries of the brains and beauty of the time. It would have been easy for Man to reach the level of a court photographer, but he was more interested in making portraits of his friends. He easily won their admiration by the quality of his work and by his generous nature. At an early date, he was introduced by Picabia to Jean Cocteau who, although despised by Dadaists and Surrealists as trivial, was a help to Man because of his wide circle of adoring friends in Paris. Cocteau's love of America, which encompassed even westerns and jazz, was an attraction and, after Man Ray had made a very successful portrait of him, he began to bring to the hotel/studio in Montparnasse an increasing number of those eager for portraits of such quality. 'No one paid for the prints,' says Man, 'but my files became very imposing and my reputation grew.'[37]

Among those who came to sit for him were some, including even Gertrude Stein, who disapproved of the sense of humour that made his painting and his objects incomprehensible to them and who were disconcerted by his flashes of genius. But there were also artists, poets and musicians, such as Picasso, Matisse, Braque, Max Ernst, Derain, Picabia, Brancusi, Le Corbusier, Sinclair Lewis, James Joyce, Satie, Schoenberg and Stravinsky, who recognized the formidable authority with which Man Ray could make a portrait. For the Surrealists, he became the photographer of their choice. Among the many portraits of his friends are photographs of Breton, Eluard, Desnos, Duchamp, Tzara, Peret, Tanguy, Masson, Miró, Dali and many others, as well as numerous groups, constituting a complete and vivid history of the Surrealist movement in the heroic years of its activity.

The excellence of these portraits does not depend on dramatic lighting effects, nor on carefully arranged settings. It comes from an acute understanding of the way that character resides in the shape of a head and the manner in which the events of a life

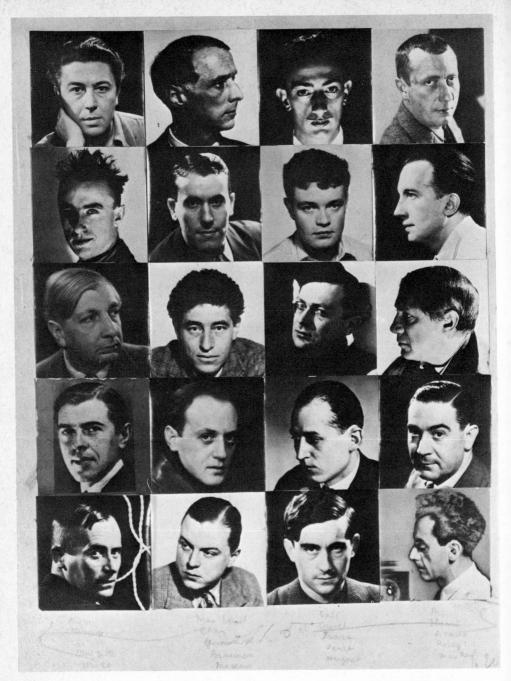

43 *L'Echiquier surrèaliste* 1934. Left to right, top row: Breton, Ernst, Dali, Arp; second row: Tanguy, Char, Crevel, Eluard; third row: de Chirico, Giacometti, Tzara, Picasso; fourth row: Magritte, Brauner, Péret, Rosey; bottom row: Miró, Mesens, Hugnet, Man Ray

44 At Tzara's 1930. Left to right, back row: Tzara, Arp, Tanguy, Crevel; in front: Eluard, Breton, Dali, Ernst, Man Ray

are engraved on a face. The prints are not the winning choice selected from hundreds of snapshots but individual studies carefully planned with patience and experience, into which nevertheless an element of chance is always allowed to enter. The essential factor, however, is Man Ray's vision as a painter and his consciousness of the form that light gives to a head. André Breton showed his appreciation of Man Ray's rare ability when he described 'this eye of a great hunter, this patience, this sense of the moment pathetically right, when equilibrium between reverie and action, however fugitive, establishes itself in the expression in a face'.[38]

The Surrealists

As it grew in number and intensity, the Surrealist group passed through a continuous maze of crises, but miraculously remained united in its activities. Those who frequented Breton more closely, in the cafés of Montmartre, were suspicious of the group that formed round André Masson and Antonin Artaud in the rue du Château near Montparnasse. It was with this latter faction that Man Ray, in the twenties, had more contact, meeting them in cafés such as Le Dôme and La Rotonde and finding

entertainment with them at night at Le Jockey, Le Jungle or Le Bal Nègre. However, the work that began to involve him with the brilliant world of fashion in Paris, while it provided him with a living, also kept him somewhat aloof from the bubbling cauldron of Surrealist activity.

Already in 1922, Man Ray had been invited to take part in the Salon Dada, the first international Dada show, and during the years that followed no exhibition promoted by Dadaists or Surrealists was complete without him. The first monograph on his work to appear was compiled by Ribemont-Dessaignes, one of the most active supporters of Dada from its earliest days in Paris, and one who attacked Breton ferociously when the split came, calling him a 'policeman and a priest' and deeply offended by his pontifical treatment of former friends. The small monograph, dated 1924, contains twenty-seven illustrations of the work of Man Ray. In a long, enthusiastic preface, Ribemont-Dessaignes discusses not only the paintings but also the photographs and objects; he suggests that Man Ray, though apparently simple and tranquil, has

unfastened the shutters of a surprising universe. Contemplating the components, it is astonishing to recognize how these things, or these objects of dreams, have the faculty of being at the same time this or that, and of changing their personality at the very moment they appear to have been grasped. . . .[39]

In the same year, Man Ray appeared in *Entr'acte,* a film made by René Clair with the assistance of Duchamp, Picabia and Erik Satie. A year later he exhibited at the Galerie Pierre, in the first Surrealist exhibition, with Arp, de Chirico, Ernst, Masson, Miró and Picasso. He had in fact become indispensable in all branches of Surrealist manifestations, although when he was asked to sign their manifestos he invariably declined. The review published by the group, *La Révolution surréaliste,* began in December 1924 with a photograph of Man Ray's object 45 *L'Enigme d'Isidore Ducasse,* which was an invisible object wrapped up in black cloth. This work initiated the popularity

45 *L'Enigme d'Isidore Ducasse* 1920

of wrapped objects which, through the persistence of Christo, have recently been seen throughout the world. Man's photographs or Rayographs, or reproductions of his collages, objects or paintings are to be found, often uncredited, in almost every number of *La Révolution surréaliste*. With his natural generosity and independence, Man never complained and often proposed photographs by other 'anonymous' photographers, such as the veteran Arget who lived near by and specialized in hallucinatory versions of everyday street scenes.

Le beau-monde

A few months after his arrival in Paris, Man Ray had been introduced by Picabia's wife, Gabrielle, to the celebrated fashion

designer Paul Poiret. Man Ray was attracted, not only by the glamour that surrounded him and his revolutionary ideas of liberating women from the servitude of nineteenth-century decorum, but also by the chances Poiret offered at last of a reasonable recompense for his work as a photographer. Poiret was also a man of daring good taste and owned a collection of important works by the more advanced artists, including some splendid glittering bronzes by Brancusi. Without knowing just what Poiret might require of him, and having nothing more to show than the portraits he had made of his friends, Man found that much to his surprise he was at once accepted as a fashion photographer.

In his *Self Portrait*, Man Ray gives a modest and very humourous account of his difficulties in coping with his new surroundings, which were ill-equipped for the kind of photography he intended to do. He describes the growth of his friendship with the extravagant and imperious prince of fashion, both at the height of his success and later in his pitiful decline. Man Ray's association with Poiret inevitably opened for him the doors of many society celebrities and Man soon found himself riding two horses of very different breed, one tall and white with jewelled trappings, the other dark and restive, bareback but equally proud. It was a feat that required unusual talent. The fact that Man Ray did not lose his equilibrium is remarkable and is perhaps chiefly due to the fact that he was not dazzled by riches and snobism. He knew which was the dark horse that could be trusted to carry him on an unconventional path of his own choice.

It was of this period that André Thirion wrote:

Man Ray occupied in Montparnasse an eminent situation thanks to his inexhaustible faculty for invention, his kindliness and the new methods he extracted from photographic apparatus. He astonished us all with his automobiles. He went out with very beautiful girls. Kiki for a long time has been his acknowledged mistress.[40]

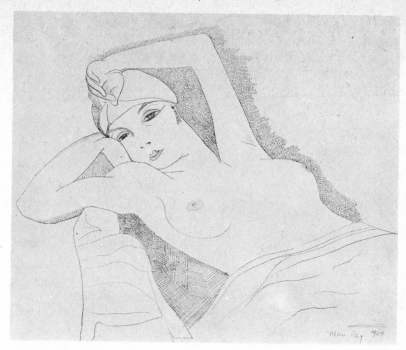

46 *Portrait of Kiki* 1924

Kiki of Montparnasse, as she was known, had been rescued by Man Ray during a spirited dispute which had arisen between her and the patron of a café because she was without a hat. This was their first meeting. She came from a small village in Burgundy and told Man that 'someday she'd go back to the country, live quietly and raise pigs'. She was earning her living as a model in Montparnasse, and was well known for her peasant-like beauty, her wit, her talent for singing erotic folk-songs and her incredible vivacity. It was not surprising that Man should find in her both an inspiration for his work and a rare companion who understood the needs of an artist and could enjoy adventure with him at a pitch in tune with the pace and excitement of his own activity. Their life, full of intimacy and affection, was perpetually stimulated by the brilliance and intelligence that was current in Paris during the twenties. Café life was animated by foreigners from all parts, but Man Ray was right in choosing as his first love in Paris a girl who combined the passionate temperament of the French with

natural elegance and a devastating wit. She could be enchantingly vulgar or disarmingly sensitive.

With Kiki as his model, Man made drawings with classical precision and photographs that had the serene beauty of the odalisques of Ingres. In particular, there is a photograph of Kiki crowned with a turban, seated in a position similar to one of the beauties in the *Bain turc* of Ingres; on her back, however, are superimposed the two sound-holes of a violin, evoking neatly the ancient metaphor of a woman's body being like a musical instrument. Man Ray gave this photo-collage the title 47 *Violon d'Ingres*, which in French is the poetic term for a hobby or a captivating pastime, and which also reminds us that Ingres was a violinist before he became a painter.

Montparnasse had become the village in which Man felt completely at home. There was the night club Le Jockey, where the songs of Kiki became an essential part of the entertainment and where a continuous flow of visitors arrived from overseas. For these Man Ray, with his intimate knowledge of the *avant garde*, his inexhaustible faculty for invention and his reputation as the master photographer, was a figure of importance. His move to a studio sufficient for his growing needs was the occasion for a wild party where local friends and Surrealist poets and painters mixed with Man's elegant Parisian admirers. At the same time, he found for Kiki a little flat in a courtyard near by, a tactful arrangement which lasted until Kiki was invited by mutual friends to visit New York.

Although Man Ray was now greatly sought after by all who admired his talent, particularly as a photographer, he was never absorbed into the wealthy aristocratic circles that would have been glad to monopolize him. Jealously preserving his independence, he was able to use their patronage to further his own inventions. Often when some accident happened as a result of his unconventional techniques, he turned disaster into a sensational victory. When the formidable Marchesa Casati sat

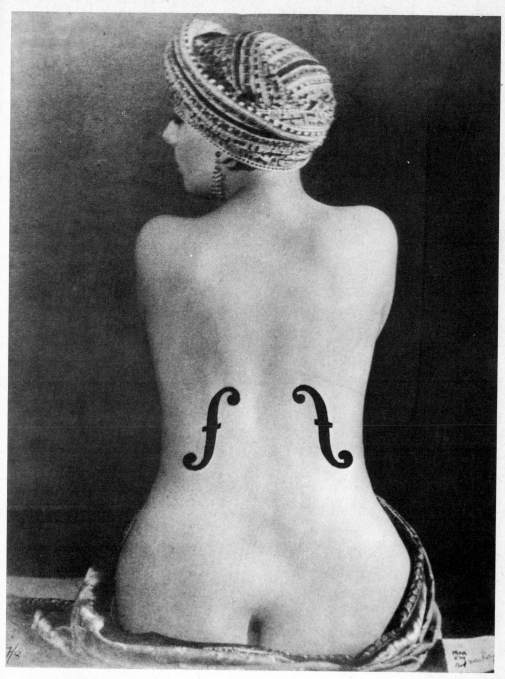

47 Violon d'Ingres 1924

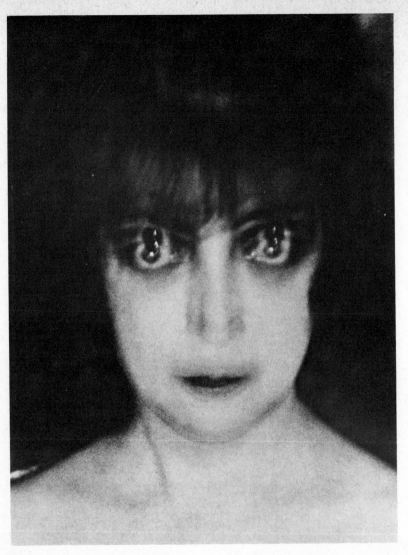

48 *La Marchesa Casati* 1922

for her portrait – a long pose in the dim light of her fabulous
drawing-room – the result was a photograph which showed
48 two pairs of eyes appearing one above the other. Man told her
that the portrait was worthless, but on seeing a print the
Marchesa was enchanted, saying that he had portrayed her soul.

Man Ray was invited to sumptuous costume balls as a guest
and as the photographer-magician who could animate the
scene and make the night memorable, either by the originality

of the lighting effects he organized or by the excellence of the portraits he took. At the ball given by the Comte and Comtesse Pecci-Blunt, to which everybody came dressed in white, Man, accompanied by his beautiful and inevitably provocative assistant, Lee Miller, devised a means of projecting from a window on to the white couples dancing below in the garden an old hand-coloured film by Méliès.

There were several society ladies who invited Man to coach them in photography, in circumstances which were often embarrassing and perilous. In his *Self Portrait* he exposes the foibles, extravagances and rare events for which his services were in demand; he went, for example, by urgent request of Cocteau, to photograph Proust on his death-bed. A major factor in his success was the simplicity with which he worked, using his camera 'like an old shoe' which he knew inside out, rather than insisting on elaborate equipment.

Moving pictures

Among his many distinguished patrons, the Vicomte Charles de Noailles and his talented wife Marie-Laure provided welcome opportunities for new ideas. He was invited by them to join a house-party in the south of France and to improvise a film in which their guests would be the actors. Georges Auric, the composer, and other friends were to be among them. On his arrival, the imagination of Man Ray was stimulated by the cubist architecture of their modern château, which appeared to him to resemble enormous dice piled up together. This suggested to him the line from a poem of Mallarmé: 'A Throw of the Dice Can Never Do Away with Chance'. The title and theme of the film became *The Mystery of the Château of Dice*. The setting and the company aroused Man Ray's capacity for invention and improvisation, and his host was so delighted with the results, described at length in the *Self Portrait*, that he offered to finance a full-length film in which Man would have

49 Man Ray in his first car 1926

complete freedom. But movie-making with all its technical encumbrance was not the path Man Ray wished to follow, and he politely refused the offer.

This was not the first time since the hasty and ephemeral improvisation for the 'Cœur à barbe' that Man Ray had turned his attention to film-making. In 1926, three years before, he began to use a small automatic hand-camera in unprecedented ways while on holiday in the Basque country. One day, in a sports-car driven by a friend, they were within an ace of massacring a flock of sheep. Man seized the opportunity of realizing the effect of a real collision by setting his camera in motion, throwing it high in the air over the hysterical flock and catching it again. With 'a hodge-podge of realistic shots and of sparkling crystals and abstract forms obtained in my deforming mirrors',[41] he collected the basic elements of a film which was to be 'a satire on the movies'; he felt, however, that it needed 'some sort of climax, so that the spectators would not think I was being too arty'.[42] Kiki and his friend the elegant Jacques Rigaut became his cast. Kiki's agile legs danced the Charleston, and a close-up showed a pair of eyes painted on her eyelids gradually disappear as she opened her own eyes. Jacques Rigaut entered with a suitcase full of shirt-collars, which he proceeded

to tear in half and throw on the floor. To this final sequence Man gave a subtitle of Dada mystification: 'The Reason for this Extravagance'. The title of the film itself was *Emak Bakia*, the name of the villa where the film was begun, meaning in Basque: 'Leave Me Alone'.

Two years later, a second film, *L'Etoile de mer*, was completed. It was inspired by a poem read aloud one evening by Robert Desnos which Man saw at once as a scenario for a film. Desnos was a brilliant exponent of Surrealism and capable of entering into trances, during which he would pour out anagrammatic phrases and write automatic poems dictated by the subconscious. From the trance, he would wake instantaneously and continue normal conversation. 'It was', as Man tells us, 'a perfect illustration of one of the Surrealist maxims: there was no dividing line between sleep and the state of being awake.'[43] In this second film, Man again used friends, two men and a woman, for the cast, rather than professional actors. Kiki was the natural choice for the woman, while Desnos and a tall blond boy who lived in the same house took the male parts. The images taken from the poem flowed in an illogical sequence and Man invented a new device which gave what he calls a 'mottled or cathedral glass effect'[44] and allowed him to film

50 At the château of the Noailles 1929

97

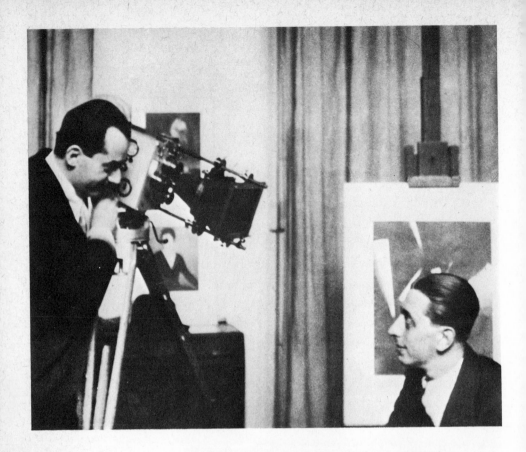

51 Man Ray and
Robert Desnos 1928

52 Frames from
Emak Bakia 1926

Kiki in the nude without the film being censored. Originally *L'Etoile de mer* was to have run for half an hour, but judicious cutting reduced it to half that time. 'I thought', said Man, 'its shortness would be one of its merits.' Indeed it was shown for two months in Paris as a short prelude to *The Blue Angel* with Marlene Dietrich but, even so, its success did not convince Man that he should pursue film directing. At the back of his mind was always his love for painting.

Motives

Despite his independent way of life, Man Ray has always kept in close contact with his friends. He has watched them, talked with them endlessly, loved them and been loved by them, influenced them and absorbed their influence, shocked them, bewildered them and made them laugh. I have stressed his mysterious conspiracies with Duchamp and the way he found an immediate response from the young animators of Dada and Surrealism whom he met in Paris. I have also described briefly his flirtation with the more banal worlds of fashion and society. From these varied sources he drew inspiration for his painting and his inventions in photography, but the sources most rich in poetic stimulus, direct or indirect, were the women he loved. Through his photographs, the statuesque torso of Kiki transformed into an instrument of music and the solarized profile of Lee Miller have become classical representations of female beauty, and there are more recent examples of images, such as the portraits of his enchanting wife Juliet and his friend Ady, a lovely girl from Guadeloupe, in which the grace, purity and compelling magic of the female presence is made vivid and permanent by his skill. Even in an album of Rayographs,[45] made in 1931 to promote the domestic virtues of electricity, with Lee Miller as his model he successfully combined the impeccable elegance of a naked torso with superimposed appropriate abstract shapes. Sex and industry were subtly united by his skill.

53 *Portrait of Lee Miller* 1930

Man Ray tells the story of an evening when he was obliged to abandon Kiki to attend a dinner-party in a very smart restaurant. He thought nothing more about her loving farewell kiss, and on his arrival at the restaurant he failed to understand his hostess's critical look; shortly afterwards, however, he saw in a mirror that a splendid impression of Kiki's lips stood out

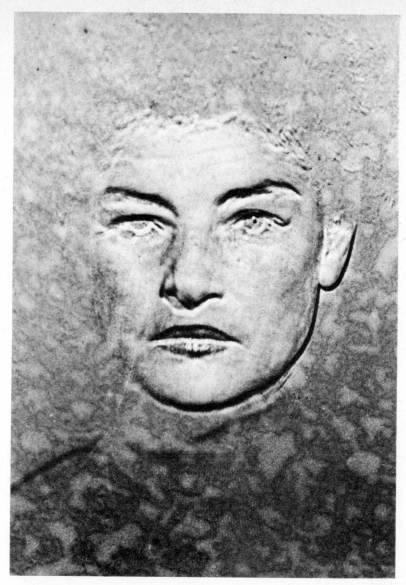

54 *Portrait of Julie* 1954

boldly on the impeccable whiteness of his collar. Far from
being an embarrassment, it set Man dreaming of lips detached
and floating with the breeze. It was a dream that remained with
him and which some ten years later he painted in monumental
style in the picture *The Lovers or Observatory Time*. The idea was
the same, but the lips had become those of Lee Miller.

59, p. 129, X

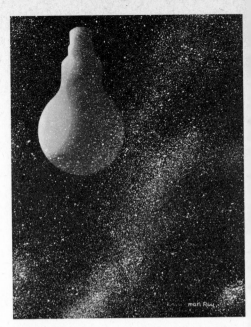

55 *La Ville* 1931

56 *Untitled* 1931

57 *Cuisine* 1931

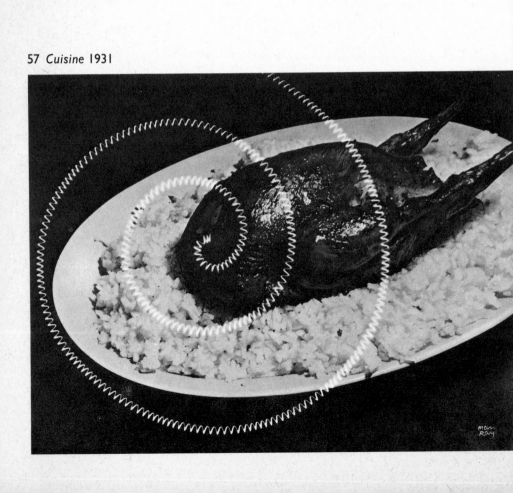

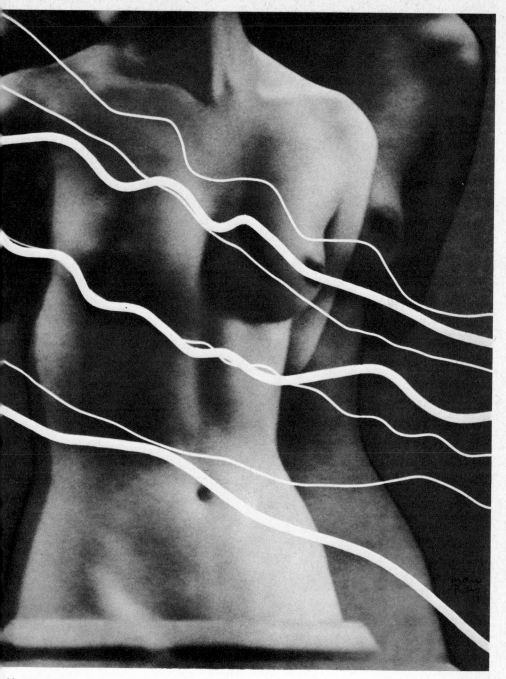

Untitled 1931

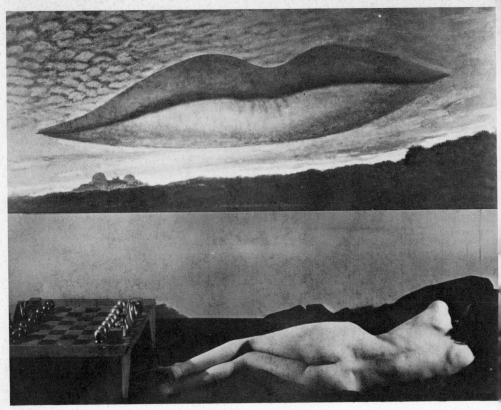

59 *The Lovers or Observatory Time*, the canvas above the divan in the rue du Val de Grâce

Man describes the persistence with which he worked for two years on this great canvas which has since become one of his most famous works. It hung for some months over his bed

like an open window into space. The red lips floated in a bluish-grey sky over a twilit landscape, with an observatory and its two domes like breasts dimly indicated on the horizon – an impression of my daily walks through the Luxembourg Gardens. The lips, because of their scale, no doubt, suggested two closely joined bodies.[46]

The Lovers and the other paintings of this period were painted in his spare time. Although his main concern during the previous ten years had been photography and his widespread reputation as a portrait and a fashion photographer had grown

steadily, he had always found time for his inventions such as the Rayographs, his objects and his films. He had also painted portraits, in 1923, of Kiki and Marcel Duchamp. Both are convincing likenesses. Kiki sits demurely dressed in brown against a blue-grey background; flesh tones take on an overall ivory

61, 62

60 *La Prière* 1930

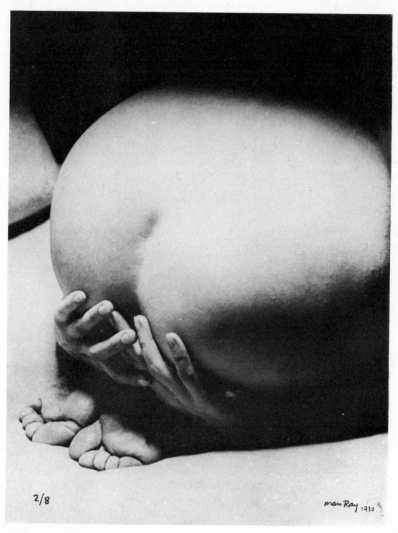

2/8

man Ray 1930

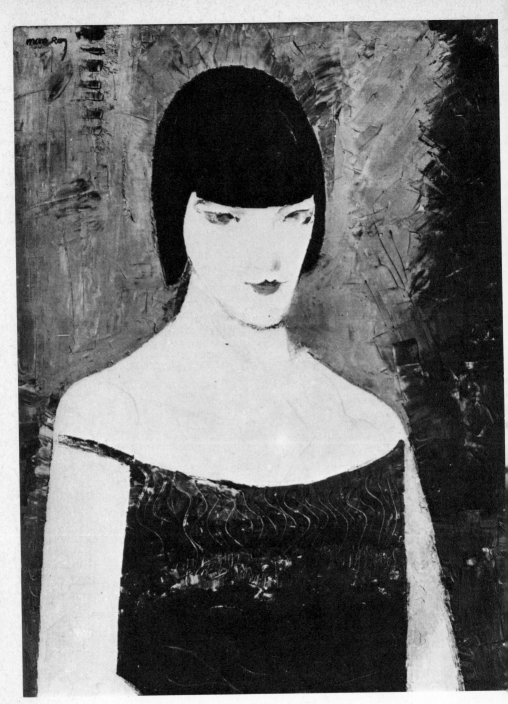

61 *Portrait of Kiki* 1923

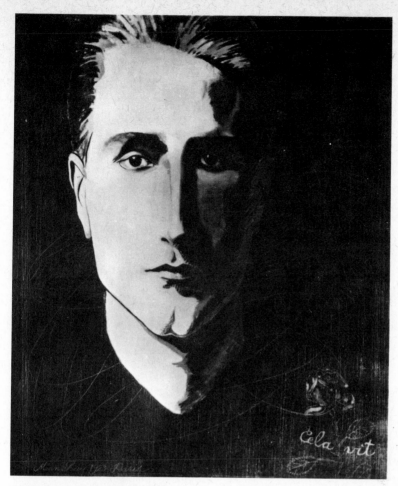

62 *Portrait of Duchamp* 1923

colour with no modelling. Her provocative eyes and lips
beneath a cloche of black hair are the same colour as the back-
ground, giving a tender but enigmatic unity between painter,
portrait and model.

For the portrait of Duchamp, Man insisted on several sittings
and worked over the painting many times to obtain a likeness
which is almost photographic in its realism. The background
is covered with lightly traced geometric figures, and in the
right-hand corner a rose is drawn above the words 'Cela vit'
– a variation on the composite pun Duchamp had invented for

his pseudonym, Rrose Sélavy. Both paintings are in unexpected contrast to the rapid, careless style that Man Ray used in paintings such as the views of Paris and the *Swedish Landscape*, which he painted the following year and in which he revels in paint rapidly and heavily applied and in wild distortions of the scene which delight us by their relevance and fantasy. It would be difficult to recognize these as the work of the same artist, were it not for Man's dexterity in the handling of contradictory styles and his love of liberty in his manner of expression. We see in these extremes his contrasting attitudes to the image, to which he may give a literal interpretation, though in general he leaves this to the camera, or which he may paint as a vision which has the illogical incoherence we find in the reality of the dream.

The crisis of the object

Man Ray's ability to play with objects had become evident before he left New York and his power to disturb their accepted definition rapidly became the delight of the Surrealists. Soon after the *Cadeau* he made for Satie, he transformed a metronome by adding to the pendulum the photograph of an eye which swayed rhythmically from side to side, keeping time with or without music. Both of these objects had the qualities of Duchamp's Readymades; their virtue lay, not in the skill required to produce them, but in the illogical surprise they created and in the fact that they could be repeated indefinitely. With Man Ray's encouragement, editions have now been reproduced in numbers which allow them to attain the status of household gods. 'To create', he reminds us, 'is divine, to multiply is human.' The title given originally to the metronome with its permanently vacillating eye was *Object to be Destroyed*. A drawing of it dated 1932 and belonging to Tzara appeared in an exhibition at the Museum of Modern Art in New York in 1936, with the title *Object of Destruction* and the following inscription on the back:

63 *Swedish Landscape* 1924

Cut out the eye from a photograph of one who has been loved but is not seen any more. Attach the eye to the pendulum of a metronome and regulate the weight to suit the tempo desired. Keep going to the limit of endurance. With a hammer well aimed, try to destroy the whole with a single blow.

These precise instructions seem to hide an inner rage, but they are also prophetic of what happened in a more impersonal way when the object was exhibited again in Paris after the war. During the exhibition it was violently destroyed by a gang of reactionary art students; Man Ray reconstructed it without difficulty and with equanimity renamed it *Indestructible Object*.

Other objects made in the twenties have a different appeal. *De quoi écrire un poème* is fragile and difficult to reproduce. Framed in oak, its dominating feature is a folded sheet of black paper, the pleats of which are transfixed by a quill pen. The originals of many of the more fragile objects have long ago disappeared, but Man has never been worried about their

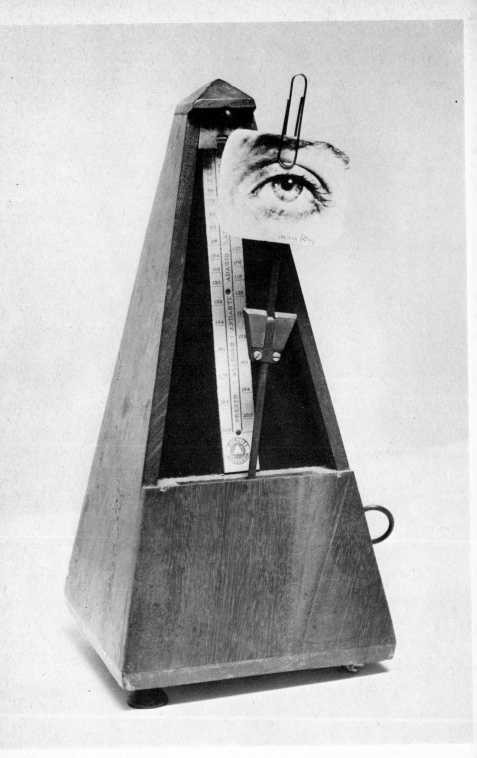

64 *Indestructible Object* 1923/58

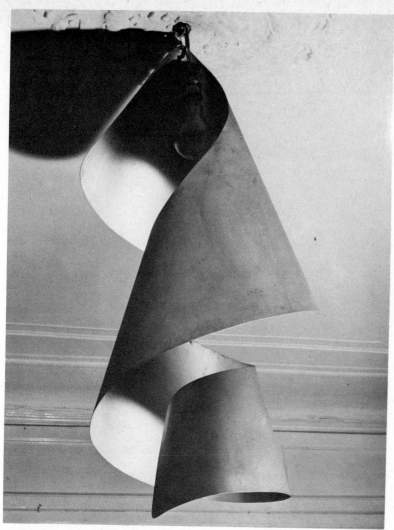

65 *Lampshade* 1919/59

ephemeral nature. Sometimes he has preserved the initial
appearance in a photograph, but he is more interested in the
persistence of the idea the objects embody. One of his earliest
inventions, the spiral lampshade made for Katherine Dreier, 65
was destroyed by a blundering janitor even before the exhibition
opened but, since it was no more than a sheet of cardboard
hanging from the ceiling, twisted and twisting in an elegant
spiral, Man had no difficulty in making a replica in painted tin,
and he afterwards repeated the operation many times.

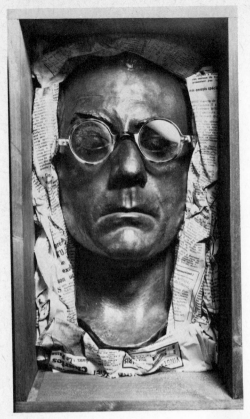

66 Self-Portrait 1932

67 Mire universelle 1933/71

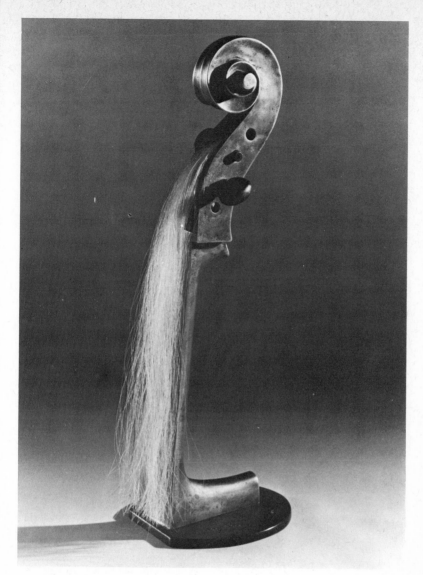

68 *Emak Bakia* 1927/70

Man Ray has occasionally invented other objects which are
more enduring. *Emak Bakia,* made at the same time as the film 68
bearing the same title, is an object captivating in the simplicity
of its form and the diversity of the poetic associations it evokes.
It consists solely of the neck of a violin covered with a tress of
blonde hair that flows down from the scroll, where we would
expect to find four taut catgut strings ready to make music.

69 *Profile and Hands*

Painter or photographer?

The flow of inventive ideas that fertilizes the atmosphere around
Man Ray owes a great deal, as I have said, to chance and to his
ability to realize rapidly the possibilities that arise from un-
expected events. For years, technologists had been aware that
during the process of developing negatives a phenomenon
they called 'solarization' sometimes occurred as a result of an
error; yet when this happened in his dark-room, Man Ray was
able to make use of the mistake to give his work a new and
unique quality. His assistant, Lee Miller, inadvertently switched
on the light while a plate was being developed and at once told
Man of her mistake. Examining the results of the accident, they
discovered that the dark unexposed background in the negative

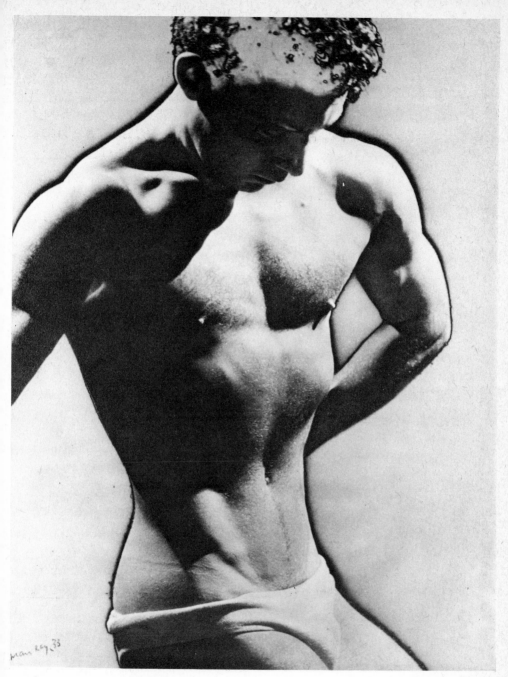

70 *Portrait* 1933

had been exposed by the light which, at the same time, had been insufficient to affect the already exposed areas. A dark, narrow gulf remained between the differently exposed areas, giving the form in the areas originally exposed an outline so sensitive as to be the envy of any painter.

Astonished by this discovery, Man Ray recognized at once the possibilities it offered and he set to work to make portraits in which the solarized plate produced profiles and accentuated form with a clarity and an assurance that brought a new sense 69–71 of three-dimensional reality into his work. It was a discovery which required the sensibility of an accomplished draughtsman to extract from it all its possibilities. Man Ray has used it with such skill that he has at times been criticized for touching up his prints, when in reality it is his use of the photographic process that is entirely responsible for such effects.

In 1934, Man Ray published an album under the title *The* 71–8 *Age of Light*, which made his photographic work accessible to the public for the first time. His introduction to the first section is an anthology of the play of light on a wide collection of objects, big or small, familiar or extraordinary, light-absorbent or sparkling with reflections. What is inspiring is the variety of stones, rocks, flowers, fruit, machines, ruins, mirror-reflections and eyes, indicating the breadth of Man Ray's observation as well as the brilliance of his technique. In his introduction, Man Ray makes a careful summary of the need for a poetic use of images and their power to enrich life:

For what can be more binding amongst beings than the discovery of a common desire? And what can be more inspiring to action than the confidence aroused by a lyric expression of this desire? . . . It is in the spirit of an experience and not an experiment that the following autobiographical images are presented. Seized in moments of visual detachment during periods of emotional contact, these images are oxidized residues, fixed by light and chemical elements, of living organisms. No plastic expression can ever be more than a residue of an experience.

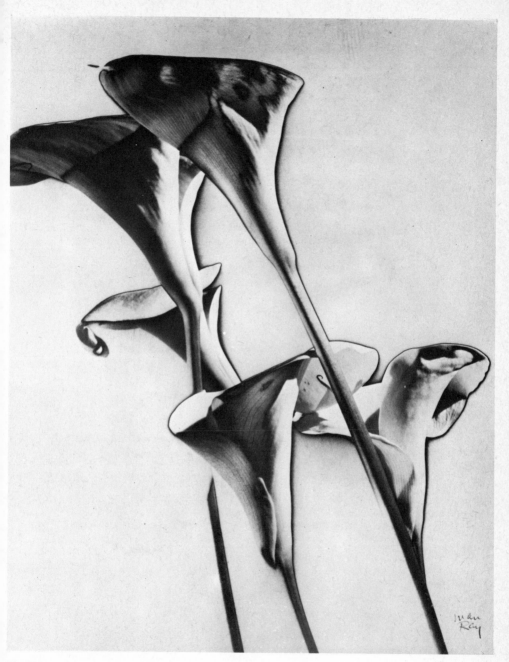

71 Solarized photograph 1932

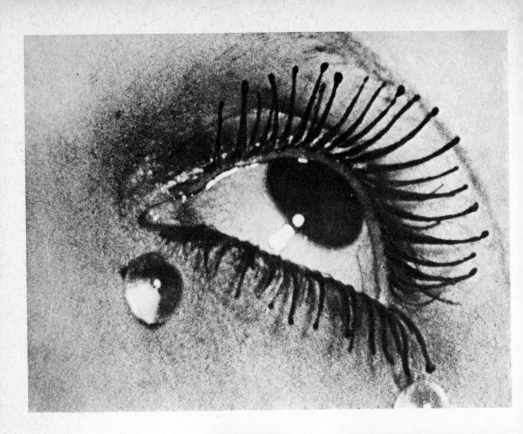

72 Photograph from
The Age of Light (1934)

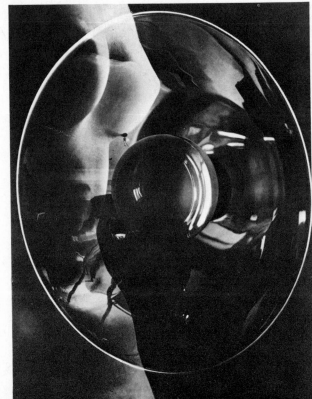

73 Photograph from
The Age of Light (1934)

74 Photograph from
The Age of Light (1934)

75 Photograph from
The Age of Light (1934)

76 Solarized photograph from
The Age of Light (1934)

77 Solarized photograph from
The Age of Light (1934)

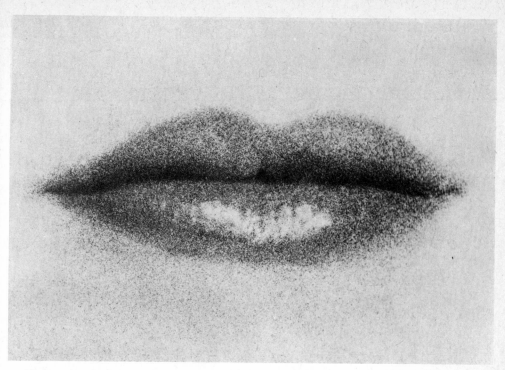

78 Solarized photograph from *The Age of Light* (1934)

The second section contains photographs of the female nude, presented with masterly detachment and a rare appreciation of female beauty. It is accompanied by a poem by Paul Eluard and is followed by 'The Visages of the Woman', a series of portraits introduced by André Breton. 'It is of Man Ray alone', he writes, 'that we may expect the real *Ballad of Women of the Present Day,* of which it is possible to give only an extract in this collection.'[47] Except for the last portrait, which is of Gertrude Stein, the women remain anonymous, but in the following section, a series of male portraits with a preface by Duchamp signed 'Rrose Sélavy', all the sitters are identified with the exception of the last, who is in fact Babette, the music-hall female impersonator. After analysing the reactions of the sitter to 'the mirror [that] imprisons them and holds them firmly', Duchamp concludes: 'This face, always this face which they know so well. For they have a body only at

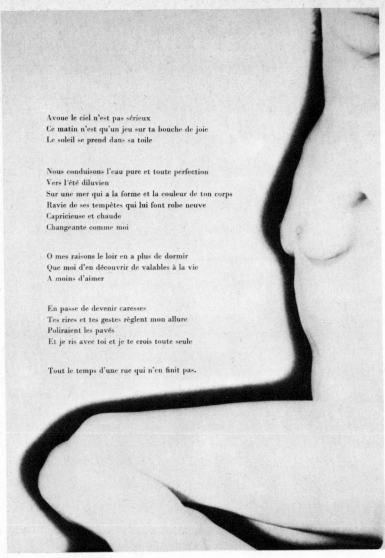

Avoue le ciel n'est pas sérieux
Ce matin n'est qu'un jeu sur ta bouche de joie
Le soleil se prend dans sa toile

Nous conduisons l'eau pure et toute perfection
Vers l'été diluvien
Sur une mer qui a la forme et la couleur de ton corps
Ravie de ses tempêtes qui lui font robe neuve
Capricieuse et chaude
Changeante comme moi

O mes raisons le loir en a plus de dormir
Que moi d'en découvrir de valables à la vie
A moins d'aimer

En passe de devenir caresses
Tes rires et tes gestes règlent mon allure
Poliraient les pavés
Et je ris avec toi et je te crois toute seule

Tout le temps d'une rue qui n'en finit pas.

79 Page 4 from *Facile* (1935)

night and most only in the arms of a woman. But with them goes always, ever present, their face.'[48] As we turn the pages we meet most of the Surrealists, including Duchamp himself, and many others, poets, painters, sculptors, architects and musicians, a portrait gallery of rare distinction.

Finally Tristan Tzara, appropriately, introduces the Rayo-

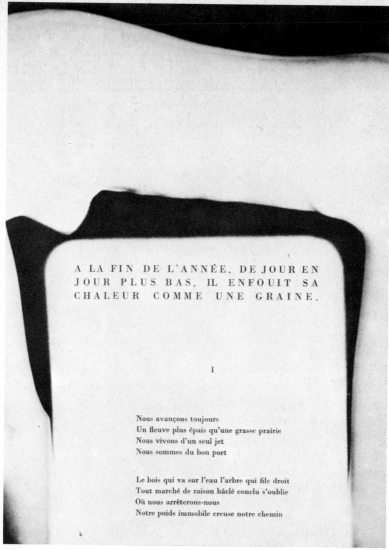

A LA FIN DE L'ANNÉE, DE JOUR EN
JOUR PLUS BAS, IL ENFOUIT SA
CHALEUR COMME UNE GRAINE.

I

Nous avançons toujours
Un fleuve plus épais qu'une grasse prairie
Nous vivons d'un seul jet
Nous sommes du bon port

Le bois qui va sur l'eau l'arbre qui file droit
Tout marché de raison bâclé conclu s'oublie
Où nous arrêterons-nous
Notre poids immobile creuse notre chemin

80 Page 5 from *Facile* (1935)

graphs of the twenties, with a prose poem which rings with
sober sincerity and which ends: 'These are projections surprised
in transparence, by the light of tenderness, of things that dream
and talk in their sleep.'[49]

This album was followed by another book in which Man
Ray's genius for making images of the nude again showed

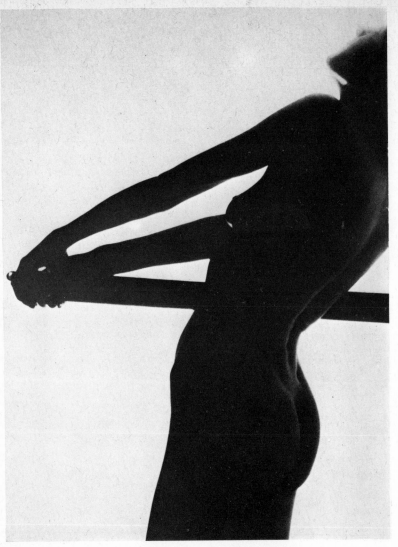

81 Page 7 from *Facile* (1935)

itself. Man had known Paul Eluard since the day he arrived in
Paris, but it was during the thirties, when Eluard was one of the
most active leaders of the Surrealist group and was also closely
united with Picasso, that Man Ray found himself drawn by the
magnetic personality of the poet, who had recently married
Nusch, his second wife and a girl of exceptional grace and

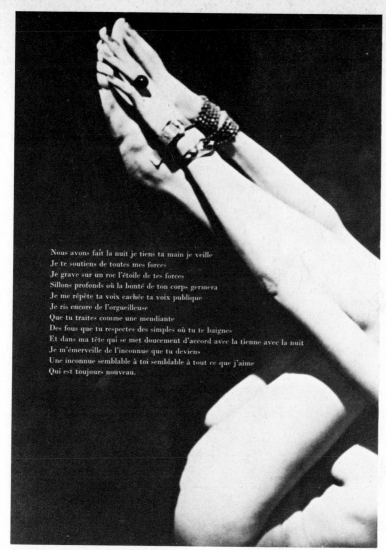

Nous avons fait la nuit je tiens ta main je veille
Je te soutiens de toutes mes forces
Je grave sur un roc l'étoile de tes forces
Sillons profonds où la bonté de ton corps germera
Je me répète ta voix cachée ta voix publique
Je ris encore de l'orgueilleuse
Que tu traites comme une mendiante
Des fous que tu respectes des simples où tu te baignes
Et dans ma tête qui se met doucement d'accord avec la tienne avec la nuit
Je m'émerveille de l'inconnue que tu deviens
Une inconnue semblable à toi semblable à tout ce que j'aime
Qui est toujours nouveau.

82 Page 8 from *Facile* (1935)

vivacity. Between them, Man Ray and Eluard produced *Facile*, 79–82
a book of Eluard's poems expressing his love for Nusch,
illuminated by Man Ray's photographs of her in the nude
which are skilfully combined with the typography of the poems.
It is an admirable work of love and tenderness, which in spite
of its purity was at the time considered quite indecent.

Surrealism grows

The 1930s brought a period of intensive activity among the Surrealists and as usual Man Ray's work was greatly in demand for individual exhibitions, group shows and full-page photographs in reviews such as the *Cahiers d'art* and particularly the *Minotaure*, several numbers of which are edited by Breton and Eluard. Surrealism had for ten years been treated generally as a childish pastime or a public nuisance; now its concern with the complete revolution of values in the arts and in life had come to be considered as a force of undeniable strength in the intellectual world. Its influence was widespread. After the first international Surrealist exhibition had taken place in the Canary Islands in 1935, the London exhibition the following year greatly augmented the movement's credit abroad. Man Ray was active in helping Breton and Eluard to select the exhibits and the result was a memorable exhibition which opened to large crowds in June 1936 and shook the British out of their supercilious disdain for Surrealism. Besides numerous works by de Chirico, Picasso, Picabia, Duchamp, Klee, Magritte, Ernst, Masson, Tanguy, Miró, Dali, Arp, Brancusi, Calder, Hayter and Giacometti, it contained British contributions by, among others, Moore, Nash, Sutherland, Jennings and Burra. Man Ray was well represented with large paintings. *The Rope Dancer* and *The Lovers or Observatory Time* were among his twenty-four exhibits, which included drawings and Rayographs, together with six photographs of mathematical objects which Man Ray and Max Ernst had discovered in the Poincaré Institute in Paris and which, in their precise demonstration of mathematical problems established in three-dimensional form, became later the basis of a series of paintings. Among them in particular were the *Shakespearian Equations,* which I shall discuss in greater detail later.

In December 1936, the Museum of Modern Art in New York organized an international exhibition of Fantastic Art,

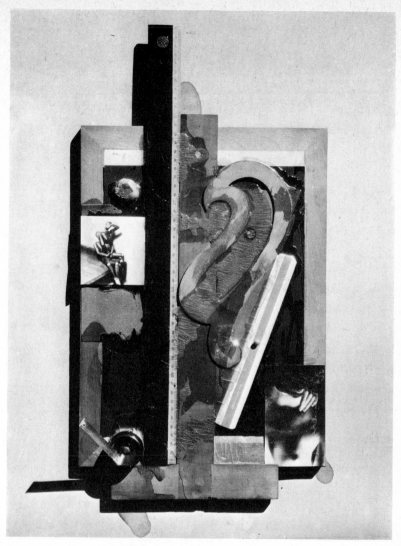

83 *Collage, ou l'age de la colle* 1935

Dada and Surrealism. Again, Man Ray was well represented
with important works. But the exhibition to which he and
Duchamp contributed most liberally was held in Paris in
1938, again with the full support of Breton, Eluard and the
whole Surrealist group. The catalogue appeared as an abridged
dictionary of Surrealism and an announcement was added,
stating: 'Ceiling covered with 1,200 sacks of coal, revolving
doors, Mazda lamps, echoes, odours from Brazil and the rest

in keeping.' The sacks were the invention of Duchamp, and Man Ray devised the lighting, which came mostly from braziers placed near the centre of the gallery. Outside the entrance was an old taxi which Dali had arranged so that inside it was pouring with rain and a half-naked manikin on the back seat was crawling with live snails. From there, along a narrow passage leading to the main exhibits, were placed a line of elegant female shop-dummies, each one of which had been decorated by a Surrealist painter. The whole series was recorded photographically with skill and devotion by Man Ray.

During these years, when the sense of approaching catastrophies was made suddenly more acute by the insurrection of General Franco in Spain, the friction arising between Breton and Eluard as a result of their political beliefs became increasingly intense. Man Ray, however, with his usual detachment, succeeded in remaining friendly with both, although he was closer to Eluard, with whom he often spent the summer months in Mougins, near Cannes, in the company of Picasso and Dora Maar. With Man Ray came Ady, the delightful girl from Guadeloupe, who could swim, laugh and dance like a brown angel.

In Paris, Man Ray moved to a large and well-appointed studio. He had three main pursuits: photography, in which his reputation now allowed him to control his commitments and which he continued only for his own satisfaction; painting, to which he was returning with new enthusiasm; and drawing, his most consistent occupation. In painting, he had turned increasingly to subjects that originated in dreams and to situations painted realistically but existing only in the imagination and therefore impossible to photograph; an example is *La Fortune,* in which the green baize on a billiard-table rears up into a barren landscape against a sky full of brilliantly coloured cotton-wool clouds. Others such as *The Poet (King David), The Misunderstood One, Easel Painting* and *The Woman and Her Fish,* painted the same year, are all admirable in their execution

p. 129, XI

84
p. 130, XII,
85, 87

X *The Lovers or Observatory Time* 1932–4
XI *La Fortune* 1938/41

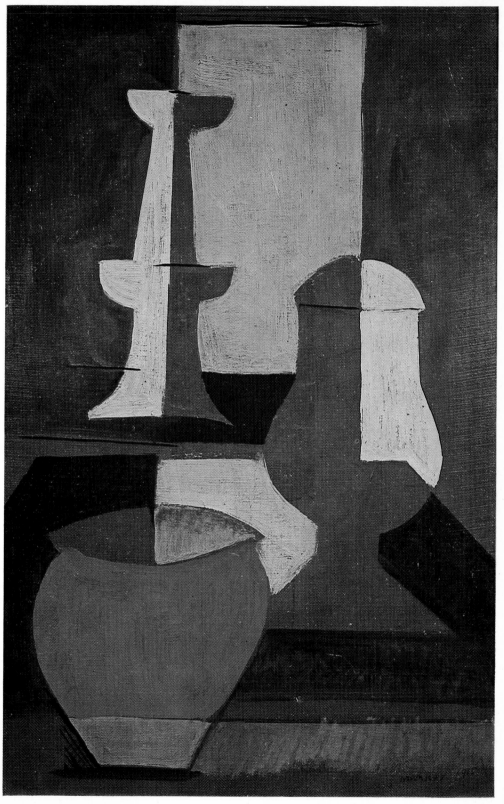

IV

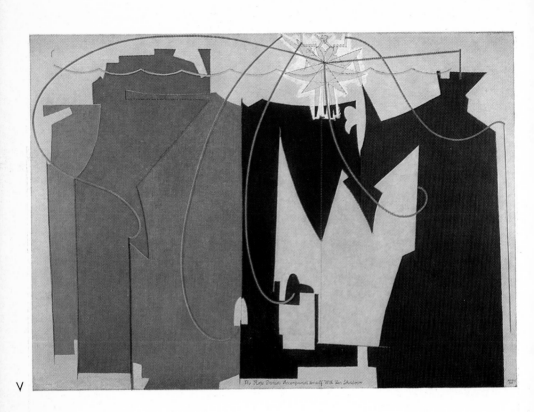

The Flute Player Accompanies Himself W.R. Van Stockum

V

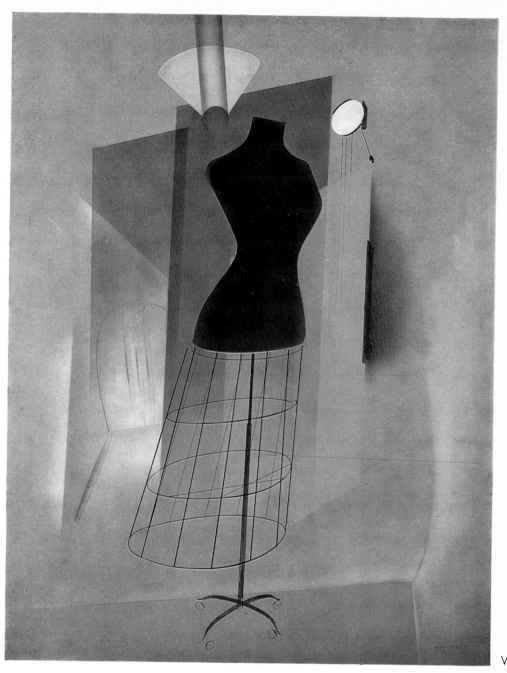

VI

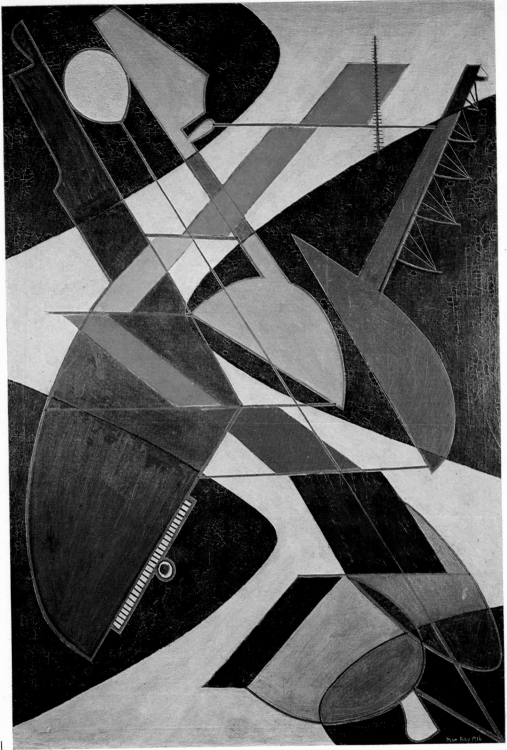

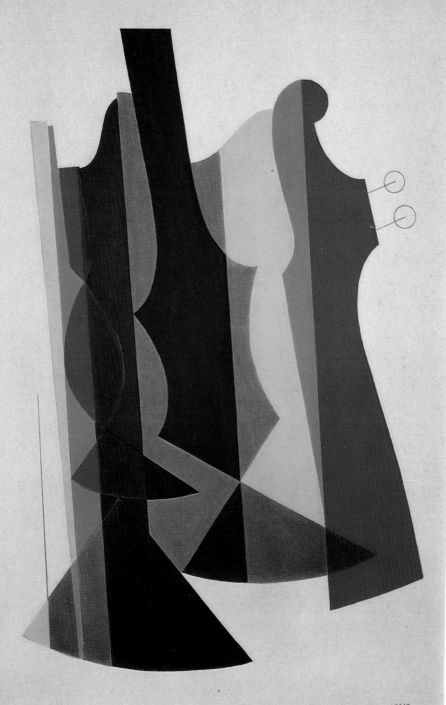

man Ray 1942

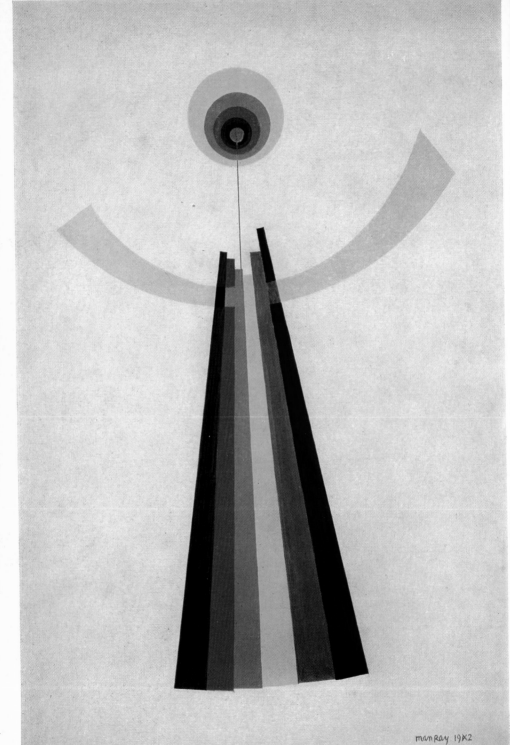

X

XI

XII

XIII

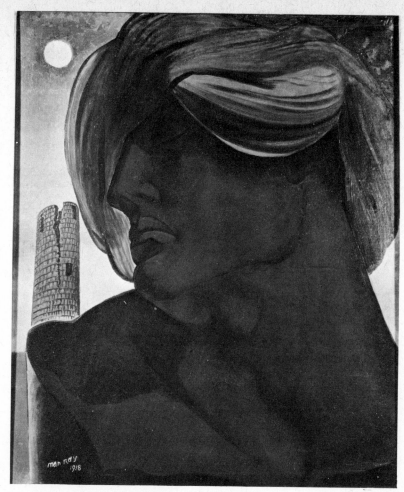

84 *The Poet (King David)* 1938

and in the clarity with which the subject is presented. As images, they are disconcerting; Man Ray has always claimed that 'logic assassinates', and the irrational haunts the paintings.

The last large painting made by Man Ray before life was interrupted by the war is in many ways a condensation of the deep disquiet the artist was beginning to feel. Ironically, it is given the title *Le Beau Temps,* and its bright colours at first p. 130, XIII sight appear gay and welcoming. The two figures in the foreground, male and female, are separated by a screen; they are clothed in festive costumes. Yet as we concentrate on individual

XII *The Misunderstood One* 1938

XIII *Le Beau Temps* 1939

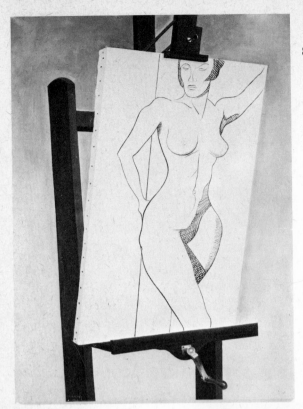

85 *Easel Painting* 1938

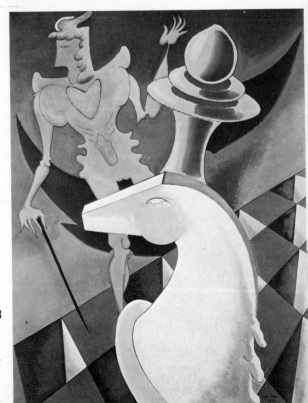

86 *Le Chevalier rouge* 1938

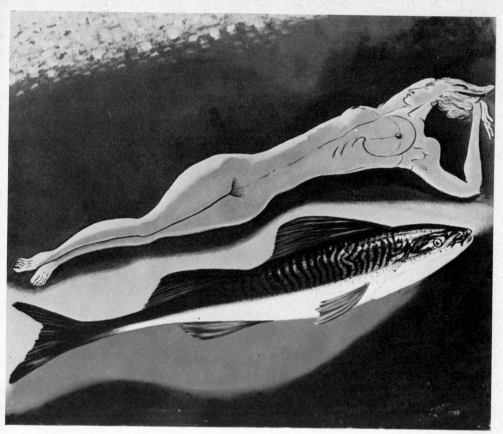

87 *The Woman and Her Fish (Pisces)* 1938

components of the composition, we discover that in each one lurks a sinister content. The head of the male figure is hollow like a lantern, reminiscent of the lampshades Man Ray had designed in his youth; the body, in spite of its fine clothes, is disjointed like a ghost and the left hand holds a knob on the screen from which blood trickles to the ground. The female figure, with black feet showing below her carnival skirt, is a grotesque manikin. In the background we find still more disturbing happenings and signs of violence. Against a darkening sky, to the left, is a ruined wall with sinister tridents growing out of inclement soil; to the right, further back behind the female figure, is a colonnade lit from within. This harbours an easel with a canvas ready for work and the silhouette of an

embracing couple who are oblivious of the ferocious battle between two beasts taking place on the roof over their heads. These monsters appeared to Man one night as he slept in the house he had taken in Saint-Germain-en-Laye in order to be near Paul Eluard; the war had ruined their plans and that night Man was awakened by distant gunfire. When he fell asleep again, he dreamed that the two mythical animals were at each other's throats on his own roof. With these images from his subconscious Man Ray made this great painting, which is unique in his work in that his inner hopes and fears are symbolically affirmed in vivid contrast.

The poet's image

During the thirties, Man Ray made a large number of drawings while in Paris or travelling in the south of France. In every instance, we find that the work relies on a basic, simple and yet unaccountable concept. The drawings are essentially the realization of an idea or a combination of ideas that add stimulus to each other by their contrast.

Man Ray had shown these drawings to Eluard, who had asked him to leave them with him. On Man Ray's return, some weeks later, he found to his delight that his friend had 'illustrated' each drawing with a poem. The enthusiasm of Eluard was always a tremendous stimulus to those he knew, and it was he who said, 'The poet is not he who is inspired but he who inspires.' This new and unexpected proof of Eluard's esteem resulted in the publication of *Les Mains libres,* a book in which more than sixty pen-and-ink drawings are reproduced, fifty-four of them opposite Eluard's poems. Among other drawings at the end of the book are two versions of an imaginary portrait of the Marquis de Sade. It was from these drawings that Man Ray later painted two other variations. In the absence of any contemporary portrait of de Sade, he was free to construct the image as he liked. He envisaged de Sade's bust built solidly in

89–95

88 *Imaginary Portrait of D.A.F. de Sade* 1938

89 *Les Tours d'Eliane* 1936

90 *Où se fabriquent les crayons* 1936

91 *Le Tournant* 1936

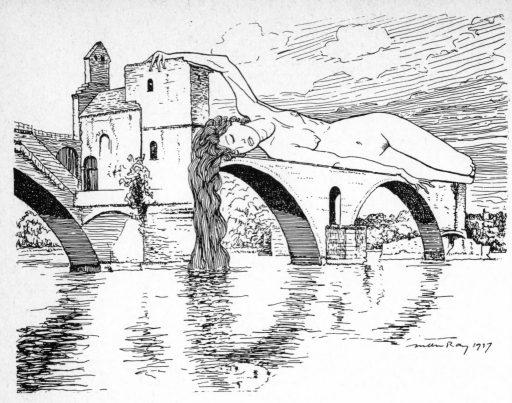

92 *The Bridge* 1937

courses of stone; behind it in flames is the Bastille, the fortress
in which the Marquis was imprisoned, now crumbling and
disintegrating. Below de Sade's massive brow, where the left
eye should be, is a cavernous gap. Man Ray did not discover
until later that his subject was blind in that eye.

Opposite the second drawing is a comment by Eluard on the
writings of de Sade: 'Written almost entirely in prison, the
work seems for ever to be in disgrace and banned. The price
that must be paid for its appearance in the light of day is the
disappearance of a world where stupidity and cowardice bring
with them all our misery.'[50]

The book begins with a drawing of the old bridge at Avignon;
the scale is reduced greatly by the presence of a naked girl
lying full-length along the arches, her hair streaming into the
water below and her arm resting on the roof of the chapel.

This is followed by Paul Eluard's preface, which was amplified for the catalogue when the pages of the complete book were exhibited, later in the year, at the Galerie Jeanne Bucher. Eluard's preface concludes: 'Man Ray draws so as not to forget himself, to be present, so that the world shall not disappear from his eyes. He draws to be loved. Desire, life, are neither happy nor sad.'[51]

The title *Les Mains libres* has of course its own significance, but in French the word *main* (hand) sounds like 'man', an international pun the artist enjoys elsewhere. *Main Ray* is the title of an object which consists of a plastic hand holding a ball. In reality, the hands of Man, instruments of his creative thought, are warm and sensitive; his fingertips in particular are like delicate tactile cushions. They are clever hands, reliable, capable of searching out hidden things and also of pointing the

93 *Belle Main* 1937

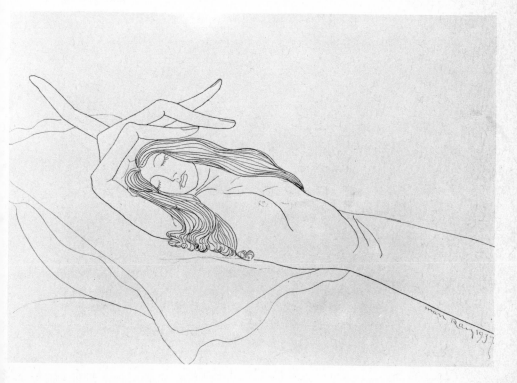

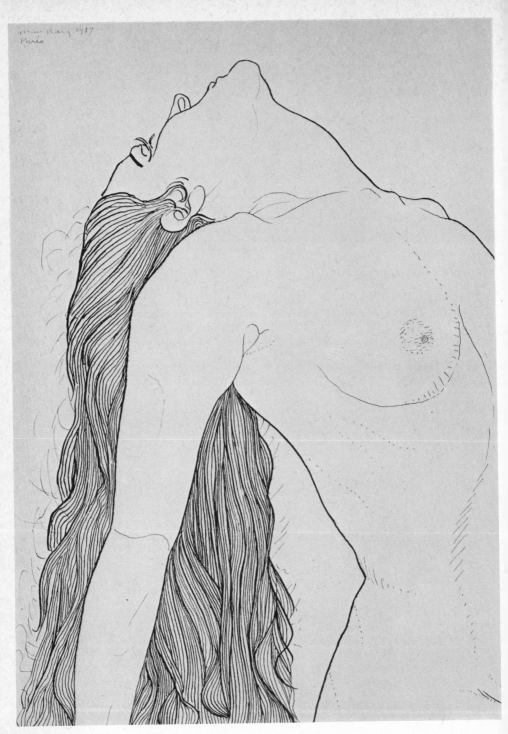

94 *Le Don* 1937

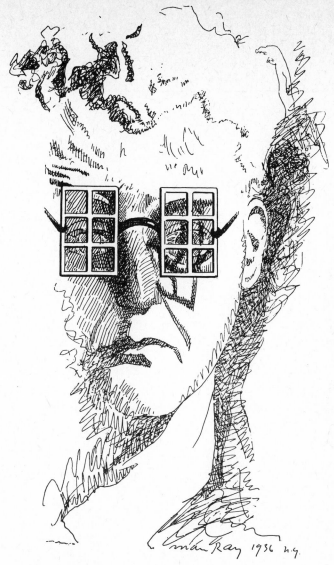

95 *Self-Portrait* 1936

way. Their freedom, both literal and metaphorical, is essential for the realization of Man Ray's frequently avowed aims: liberty and pleasure.

In contrast to the size of this volume produced by a union of painter and poet, Man Ray produced in 1937 a much smaller

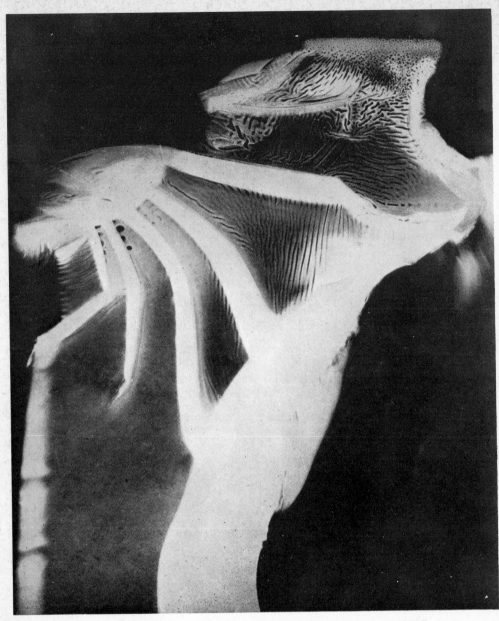

96 *Photographie intégrale et cent pour cent automatique* 1937

album, which had, however, a provocative purpose. The title,
La Photographie n'est pas l'art, was deliberately meant to tease
photographers, and yet the album consists of twelve exquisite
96 photographs of various subjects, with titles that excite the

imagination. The first photograph shows a cast taken from life of Man Ray's own head, wearing toy spectacles that he discovered in a joke shop; these are in the shape of windows, each having six panes – for multiplying vision? for protection? or, as the title of the photograph, *Dans les yeux des autres* (in the eyes of others), would seem to suggest, for the spectator to see himself? The drawing from *Les Mains libres* is another version of the same idea. The photographs that follow are a display of the marvellous creations of nature and of men: nests of ants, frogs mating, a skyscraper, Miriam Hopkins. It is impossible to distinguish between the photographs in which the effects are deliberate and those where they are the result of chance. Once more Man Ray's images are accompanied by a Surrealist text, a collection of aphorisms entitled 'Convulsionnaire', by André Breton, who had stated in his book *Surrealism and Painting* that 'beauty must be convulsive or cease to be'. Here he had found an appropriate example, and the enigmatic images of Man Ray were once more a source of inspiration for a Surrealist poet.

The first part of the book is headed 'Hommes' and the second, 'Femme'. Among the aphorisms addressed to the male, we find, 'May the wind drop when I try to direct my dreams' and 'I would like to be able to change sex like a shirt', whereas for woman he has only one message: 'Seduce the whole world like the rising sun! Failing that, never grow old.' This leads up to the conclusion: 'But here is Man Ray. HERE IS THE MAN WITH THE HEAD OF A MAGIC LANTERN.'[52]

97 *Infinite Man* 1942

3 Hollywood 1940–1951

Fall and rise of Surrealism

The defeat of the French army and the occupation of Paris in 1940 brought with it a dispersal of the Surrealist group from which the movement never recovered, although the ideas it evolved continue to be an influence of lasting importance. With Paris in imminent danger, Man Ray loaded into his car his most essential belongings and made off towards the Atlantic coast with his faithful companion, Ady. In *Self Portrait* he describes their bewilderment at finding themselves fleeing with a flood of distraught refugees across the summer landscape of France. At length, exhausted, they were overtaken by the invading troops; Man Ray tells us how he persuaded some German officers to allow him to siphon petrol out of a captured British tank, and how he then raced defiantly past them on the road back to Paris. The misery and isolation he felt in that conquered and deserted city run by Nazi troops was unbearable and so, as an American citizen, he managed eventually to find his way back to the States, leaving his house, his studio and his work in the hands of the devoted Ady, who had decided to stay with her family in France. Taking the only possible route, through Spain and Portugal, and meeting by chance on the way a few friends such as Virgil Thompson, Salvador Dali and René Clair, all in the same plight as himself, he finally arrived in New York. There he could have joined the small colony of Surrealists that was slowly drifting in. Centred round Breton and encouraged by American friends, a group including Duchamp, Max Ernst, Masson, Tanguy, Dali and several others was to grow in strength and attract to it a number of New York artists and poets.

Man Ray, however, chose his own path. Passing through New York almost unnoticed, he set out for the West Coast. The trip by road across the continent was to him a new experience, for he had never before been beyond the western limits of New York State. Finally arriving in Los Angeles, he embarked on the discovery of Hollywood. The disruption of his life had come as a crushing blow; he had lost his home, his work, his friends and the French way of living that he had adopted with such ease and enjoyed so thoroughly. But chance again was to favour him.

His first stroke of unbelievable luck was to find at the house of a friend a girl with an enchanting personality, faun-like features, sparkling black eyes and a detachment that increased her exotic flavour. She was already favourably disposed to Man Ray, having heard something of his talent and achievements, and moreover she had studied modern dance with Martha Graham, an asset of great importance to Man, who has always enjoyed dancing. Being small and agile and possessing a perfect sense of rhythm, he was a clever and competent partner who invented his own steps and often danced all night with inexhaustible energy and precision. 'Juliet', says Man 'was like a feather in my arms.'[53] Indeed they seemed made for each other; this still holds true after more than thirty years.

The discovery of a new world took place hand-in-hand with Juliet. After a few weeks, they found an apartment with a studio of reasonable size in the centre of Los Angeles, situated neatly in a courtyard off Vine Street where palm trees and flowers grew in front of their door. In its seclusion and its ivy-covered walls was something that recalled Paris, even though just outside, in the boulevard, was the irrepressible activity of Hollywood. To complete this resurrection, Man Ray found a powerful streamlined four-seater car which fulfilled once again his love of elegance, speed and a well-designed machine. Its purchase formed a link with the past, for the

98 Juliet 1946

sportscars of Picabia and Derain had enlivened his early days in Paris and he emulated them by owning a very special model of a fast French car. This new toy, however, being much more powerful, soon became the cause of arguments with the Los Angeles speed-cops.

99 Man Ray in Hollywood 1948

The new situation in which Man Ray found himself, after the destruction of the life he had created for himself since his arrival as an eager explorer in Paris twenty years before, enabled him to write:

Well, now I had everything again, a woman, a studio, a car. The renewal of my existence every ten years, as predicted by an astrologer, was running true to form. Having provided for my immediate material needs, I could now concentrate on the long-range project of re-establishing myself as a painter. There was plenty to do. Besides the reconstruction of apparently lost works, I had sketches and notes for new ones which I hadn't had time to realize in Paris. When finished, I could truthfully use one of my favourite expressions: I had never painted a recent picture.[54]

Objects of my affection

Rapidly Man Ray re-established an atmosphere of his own. Since the original collages of certain works, such as *The Revolving Doors,* had deteriorated, he remade them, this time with oil-paint on canvas, larger in size but with all their original brilliance of colour. He painted new versions of other works, the *Portrait of the Marquis de Sade* and *La Fortune*; works such as *Infinite Man,* however, were large and entirely new. He also 97
returned with new inspiration to the invention of objects. His *Objects of My Affection,* when presented together in New York later, proved that his ability to conjure with objects in disturbing and diverse ways was undiminished. He wrote in his preface to the catalogue:

In whatever form [the object] is finally presented, by a drawing, by a painting, by a photograph or by the object itself in its original material and in its original dimensions, it is designed to amuse, bewilder, annoy or to inspire reflection, but not to arouse admiration for any technical excellence usually sought in other works of art.

The uncertainty of existence was reflected in the nature of his objects, but his suspicion of the world was tempered by his affection, not only for his friends, but also for the humble, absurd and yet often beautiful objects which are a part of our lives.

100 *Le Témoin* 1941

101 *Repainted Mask* 1941

102 *L'A* 1941

103 *Domesticated Egg* 1943

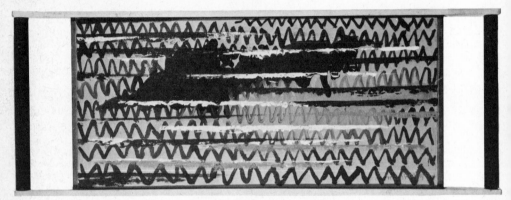

104 *Picture with a Handle* 1943

The vast straggling city of Los Angeles, stretching from the rich residential areas in the hills to the thickly-populated coast, provided Man Ray with a variety of distractions. Cocktail-parties, films, film-stars, the beach, proposals for exhibitions, the press: these could have absorbed all his time. In an attempt to cope with the eager ignorance of his admirers, Man Ray discovered an unexpected talent for lectures and discussions and began to enjoy the unconventional and provocative atmosphere he was able to create. His love of nonsense could conceal ideas that were of help to those who had the wit to understand him. An exhibition in Pasadena of his paintings, drawings and Rayographs gave him the opportunity to give some impromptu

05 *Mr Knife and Miss Fork* 1944

106 Man Ray and
Ava Gardner 1950

talks to visitors and students, staving off any possibility of
boring his audience by provoking them into a continuous
exchange of questions and sincere but enigmatic answers.
When asked, as he was frequently, if he admitted that modern
art could have a bad influence on the young and, if it did, what
could be done about it, he replied:

There is . . . your high bridge in Pasadena from which every
once in a while someone jumps off, committing suicide. There
is no question of removing the bridge. . . . To me, a painter, if
not the most useful, is the least harmful member of our society.
An unskilled cook or doctor can put our lives in danger. I have
tried . . . to paint a picture that would, like the beautiful head of
Medusa, turn the spectator to stone . . . but I have not yet
succeeded.[55]

XIV *Retour à la raison* 1939
XV *Merry Wives of Windsor* 1948

XIV

XV

XVI

XVII

Man Ray knows that he is not an orator with a masterly command of rhetoric. He makes his effect rather in short rasping phrases that turn things topsy-turvy and inside-out. His remarks are usually contrary to what is expected and he drives home his point with slow insistence. His wit and his modesty, combined with his enthusiasm and his ability to express himself in such a way that his comments seem addressed personally to each individual present, made such improvised gatherings very popular. More important to him, however, the discussions proved an aid to his fundamental purpose, his painting. 'Putting my ideas into words', he writes, 'was like preparing canvases and paints for a new work.'[56]

On his arrival in Los Angeles, Man Ray had been delighted to find that his old friend, the poet and collector Walter Arensberg, had settled in Hollywood, surrounded by his splendid collection of modern and Pre-Columbian art. The Arensbergs welcomed him and insisted he become a frequent visitor. As time passed, other friends entered his life, among them the film producer-director Al Lewin and his wife Millie, who had a large collection of naïve art. Al at once realized the advantage it could be to have the stimulus of Man Ray's originality and experience in his film productions such as *The Portrait of Dorian Gray* and *The Flying Dutchman*.

Another important encounter for Man Ray was his meeting with Henry Miller; they had never become acquainted in Paris but they had been neighbours there for many years and shared a nostalgia for France. 'Without exchanging many words', writes Man, 'we accepted each other, or rather took each other for granted.'[57] Henry Miller, on his side, found Man 'very disarming', quite unlike what he had expected of the 'famous American artist who had hobnobbed with the vanguard of French artists and the élite of French society'. Miller recalls Man Ray as a 'kind, gentle soul, sophisticated indeed, but affable, cordial and thoroughly sincere'.[58] They exchanged

XVI *La Rue Férou* 1952

XVII *Modern Mythology II* 1956

visits and found each other's company highly stimulating. In the forest around Big Sur, where Henry Miller had settled, was a deep pool by a waterfall, an idyllic spot where they could bathe in the nude with a sense of complete freedom. In his recollections of these days, spent with 'a man whose country was the whole wide world', Henry Miller has given a vivid description of the personality of Man and of the long conversations between them, which turned often on Man's 'hero', the Marquis de Sade. Miller speaks of

Man Ray's seeming identification with the true spirit of de Sade. Complete, absolute liberty – that is what Man Ray waxed fervid and eloquent about in describing de Sade's view of life. Total liberty! This was, and is, Man Ray's religion. . . . He was a believer without a church, so to say. He believed in life, which involves continuous creation.[59]

Other qualities of Man Ray also made a deep impression on Henry Miller: his effective way of 'demolishing pretence'; his photographic memory that to Miller made him comparable to Proust in his sense of 'the fragrance and significance of multifold association'; and his fearless, imp-like courage which suddenly appears in the face of ponderous falsehoods. This courage when confronting those more powerful than himself, together with his relatively small stature, always suggested to Miller 'David versus Goliath'.[60]

When the war was over, Max Ernst also moved west and built a house for himself in the grandiose landscape of Arizona. From this remote retreat he could visit Man Ray in Hollywood. One afternoon, Ernst arrived in Man Ray's studio with the beautiful and talented painter Dorothea Tanning and asked him to act as a witness to their marriage. It occurred to Man Ray and Juliet that it would be appropriate for them also to get married, and it was at once agreed that each couple should be witnesses to the other's wedding. After the ceremonies came sumptuous festivities at the houses of the Arensbergs and the

Lewins, and their happiness was documented by Man Ray's photographs, Dorothea's spectacular portrait of Juliet and, later, Max Ernst's large painting *Double Wedding at Beverly Hills*.

In spite of the friendly atmosphere that had grown around Man Ray, the urge to return to France had not left him. It became increasingly obvious that his heart was still in Paris. Before he left Hollywood for good, however, he was visited by Bill Copley, a young man recently out of college and completely possessed by the desire to become a painter. Bill not only admired the work of Man Ray but had developed an overwhelming passion for Surrealism. He opened a gallery in Beverly Hills and organized there lavish exhibitions of Picabia, Max Ernst, Tanguy and other Surrealist painters, as well as beginning his own collection. When he came to organize a Man Ray exhibition, Copley arranged for his new friend a resounding event. Man Ray composed an elaborate catalogue, to which he gave the modest title *To Be Continued Unnoticed* and in which he devoted a page to reviews, favourable and unfavourable, of previous shows; these included one written in Lewis Carroll's 'Jabberwocky' language, which was intended to reflect the impression Man Ray's work had made upon the critic. A thoroughly enjoyable French atmosphere was created for the exhibition's opening, which lasted late into the night. As usual, the critics failed to understand the poetic content of Man Ray's work, though Stravinsky and other friends were among the visitors who showed real appreciation.

The Copley Gallery exhibition was a mixture of watercolours, drawings, objects, photographs, chessmen and books, as well as paintings. The latter were divided into three sections: 'Shakespearian Equations', 'Non-Abstractions' and 'Paintings Repatriated from Paris'. Man Ray had made a rapid trip by plane to Paris, early in 1948, and had been able to salvage some of his work from the chaos he found in his former studio and in his house at Saint-Germain-en-Laye. These provided him with

107 *Knight's Move 1946*

a small retrospective of his work from 1912 to 1938, and
included such important canvases as *The Black Widow, The
Rope Dancer* and *The Lovers or Observatory Time.*

But the paintings Man Ray was most intent on showing were
the *Shakespearian Equations.* In his preface to the catalogue, he
refers on several pages to the origin of these canvases and to
what he considered was a misunderstanding on the part of
Breton, who had written: 'It would be falling into the trap of
closed rationalism to oppose mathematical objects with their

109–111
p. 156, XV

108 *Cactus* 1946

109 *Hamlet* 1949

arid formulas to poetical objects with more seductive titles.'[61] These paintings were in fact the outcome of the discovery Man Ray had made with Max Ernst that there could be artistic inspiration in the mathematical objects 'languishing in the dusty cases of the Poincaré Institute in Paris'. When Man Ray originally photographed these objects, they were much admired by the Surrealists and were shown in London in 1936. In Hollywood, however, Man used them as subject-matter for a series of paintings to which, with 'a certain diabolical pleasure' at the outrage this would cause to purely abstract painters, he gave titles taken from Shakespeare's plays. In his reply to Breton, he explains:

In returning to the mathematical objects as a source of material for my *Shakespearian Equations,* I proposed to myself to take

110 *Macbeth* 1948

111 *Romeo or Juliet* 1954

liberties not only with the legends but with the forms themselves, their composition, and by the addition of colour to make them as arbitrary as the most creative work could be. I was as free to do this as any painter of fruit or faces is free to choose his subject.[62]

And so Man Ray presents us with some twenty paintings, *Macbeth, The Merry Wives of Windsor, Othello* and *Hamlet* among them, which express his conviction that freedom from doctrines is essential and that the artist must staunchly refuse to be bound by categories. Two years later, with Bill Copley, who had closed his gallery, Man Ray left Hollywood for Paris.

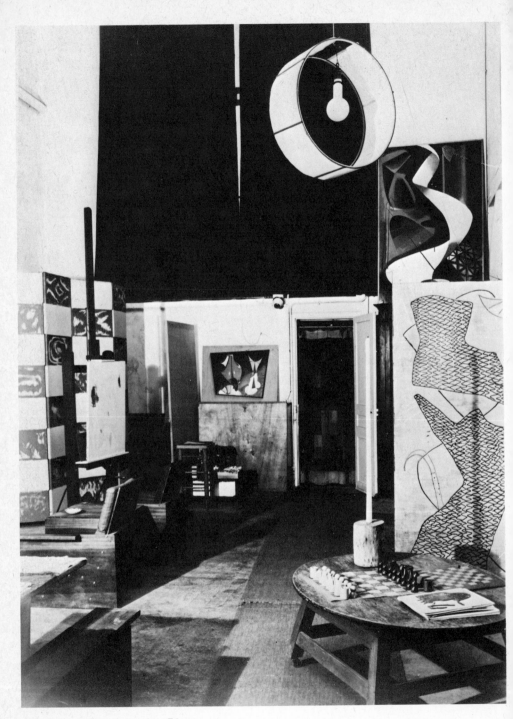

112 The studio in the rue Férou

4 Paris Again 1951

Paris preserved

The Paris to which Man Ray returned in 1951 was little changed in appearance. The bronze statues of national heroes had been taken by Hitler for cannon-fodder, but otherwise the city was apparently intact. The real wounds lay deeper. An un-reconcilable breach had opened between Surrealists such as Eluard, Aragon and Picasso, who had remained in France and taken part in the *résistance*, and those who had found refuge abroad, in particular Breton and Benjamin Péret. The former had become active members of the Communist Party, whereas the others had strengthened their allegiance to Trotsky; consequently, no further co-operation between the two groups was possible. Other former members of the Surrealist group, such as Robert Desnos, had been killed by the Nazis.

Man Ray's first priority was to find his old friends. Paul Eluard had been seriously weakened by the perils of his clandestine activity during the war; his fragile and devoted Nusch had died two years before, and Man Ray's affectionate reunion with the poet was cut short when Eluard also died, in the winter of 1952. But other friends were still vigorous and at work. Man Ray received a warm welcome from Picasso and from Max Ernst, who had recently returned from America and who was emotionally closer to Eluard than to Breton. Man has always enjoyed company and he soon found around him a growing circle of friends old and new.

Finding a studio was more difficult and could have presented a serious problem had not chance again come to his aid. In a narrow street leading from the Luxembourg Gardens to the

113 Man Ray and Juliet with Picasso, his wife Jacqueline and a friend 1956

114 *Aline and Valcour* 1950

great Renaissance Church of Saint-Sulpice, an imposing seventeenth-century building that had always interested Man Ray by the asymmetry of its towers and the romantic legends it had inspired, he found a large desolate white-washed room which had been used for many years as a sculptor's studio. Seeing the possibilities it presented, he decided despite the lack of comfort to settle there and he reconstructed the bare interior to fit his needs. This required both courage and ingenuity but, slowly, before the next winter set in, he converted the room into a studio-workshop-dark-room-living-room-library-bedroom, with the necessary sanitary and cooking fittings cleverly hidden in corners, and a large friendly stove.

The studio was lit entirely from overhead. By day, it gave one the feeling one was living at the bottom of a tank, filled to the top with light, which seemed to tremble occasionally with

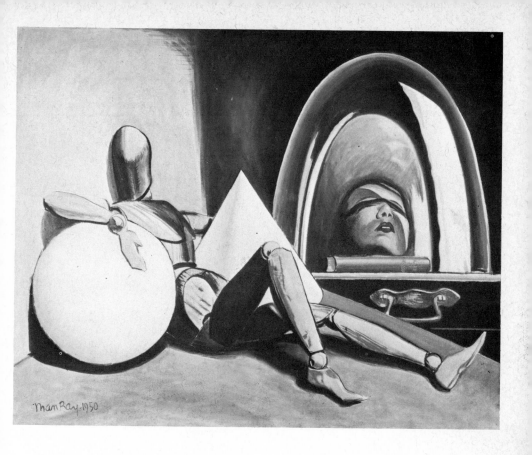

Man Ray. 1950

the deep reverberation of bells from Saint-Sulpice. At night, with his skill in handling light, Man Ray aided by Juliet soon created a mysterious atmosphere of warmth and an excitement that came from the innumerable paintings, photographs, drawings and objects that were crowded around on the furniture and on the walls and which overflowed upwards on to a balcony reserved for his work. The sense of being firmly enclosed in all directions, except overhead, proved to be invaluable for his concentration, for in its quiet isolation the space has become a hive of inventions where the ingenuity and the enigmatic wisdom of Man Ray can prosper uninterrupted.

For over twenty years, Man Ray and Juliet have made this strange introspective abode the centre of an activity which has steadily extended its influence. It is from this concentrated control-room that his fame has radiated and the value of his

115 Man Ray at Cadaques, Spain 1963

work become appreciated. Here the world comes to Man Ray, and from here his spirit has invaded the world.

At midday or in the evening, it is not unusual to find Man Ray and Juliet surrounded by friends who have come to enjoy paintings and inventions, old and new: talking, reminiscing, discussing other artists, making puns, watching television or playing chess. Chess goes back a long way. It has been almost a continual ritual since Man Ray met Marcel Duchamp and they sat over games in New York late into the night. The fascination is still there, and until his recent death Duchamp spent many hours with Man Ray absorbed in its endless problems, either in the rue Férou or at Cadaques, in Spain, when they were on holiday together. Neither of them was particularly intent on winning. For Duchamp, the interest lay in ingenious solutions to the end-game; Man Ray used even greater ingenuity in designing chess-sets, the first of which dates from 1926. 117
They varied in size and in material, the most handsome of all being a large set in silver, polished or oxidized to differentiate between opposing sides. In terms of form, however, they all have a characteristic simplicity in their geometric shapes.

But it was not only chess and their mutual appetite for puns that had held Man Ray and Marcel Duchamp so closely together since their early Dada conspiracies. The practical American iconoclasm of Man and Marcel's more imponderable and meticulous French approach to anti-art were mutually complementary. Duchamp had appreciated Man's 'achievement in treating the camera as he treated the paintbrush, a mere instrument at the service of the mind'.[63] Their close collaboration is evident in work dating from 1920; the photomontage *Belle Haleine – Eau de voilette*, which shows Duchamp disguised 118
as a woman, was conceived and arranged by Duchamp and executed and signed by Man Ray, while the *Elevage de poussière* photograph is signed by them both. On certain occasions this long and fertile collaboration has led to the kind of confusion that they both enjoy. At the opening of the Duchamp retro-

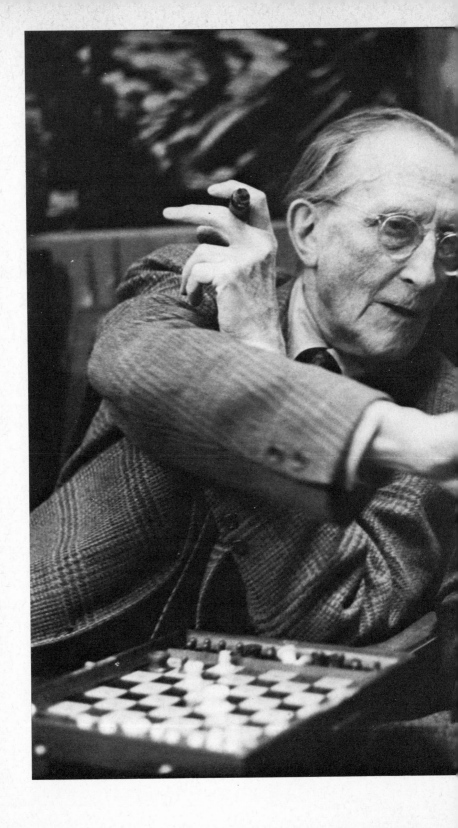

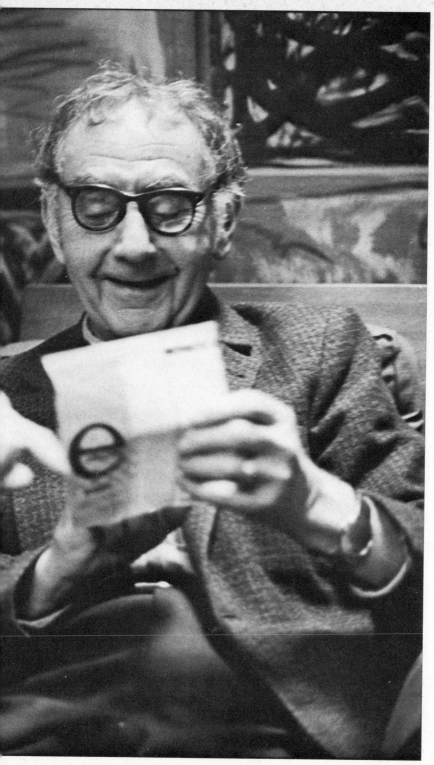

116 Man Ray and Marcel Duchamp

117 Chess Set

118 *Belle Haleine – Eau de voilette 1920*

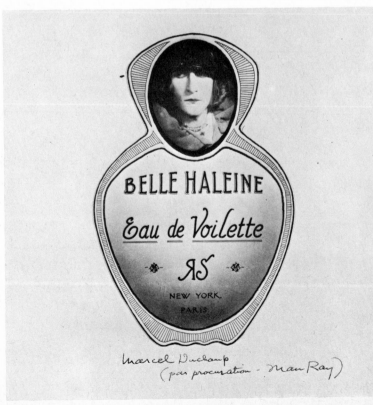

spective at the Tate Gallery in 1966, Man Ray was approached by a journalist who flooded him with searching and intimate questions, thinking he was Duchamp. Man responded with his usual charm, giving any feasible answer that came into his head and adding only as the journalist thanked him warmly and turned to leave: 'You know, I'm not Marcel Duchamp – I'm Man Ray.'

At the rue Férou, visitors arrive from all parts of the world, frequently with the intention of persuading Man Ray to sell one of his works or to allow them to arrange an exhibition. Alternatively, they may be intent on obtaining his permission to reproduce paintings, drawings, photographs or objects. There are also craftsmen who are anxious to co-operate with him in making replicas of objects, jewellery or bronzes from his designs.

Man Ray's responsiveness to this torrent of appreciation decreases as the clamour grows; he is indifferent to solicitations and has a benign impatience with fame and riches that have come to him at a time when he can no longer enjoy them in the epicurean way he would have done fifty years before. 'No,' he repeats to those who become importunate, 'I have never painted a recent picture.'

Diversity and true authority

One of the first paintings Man Ray made inside his light-tank, from which nothing of the outside world, not even the clouds, is visible, was a view of his own front door seen from the street, *La Rue Férou* (1952). Conscious of the surprise it would give to p. 157, XVI some of his friends, he painted it in a 'rather academic' style which makes it resemble a colour photograph. He writes about it with a tone of satisfaction: 'Why had I painted such a picture? they asked. I explained that I did this simply because I was not supposed to . . . and I enjoyed contradicting myself.'[64] But

aided by a 'photographic' style, Man Ray has introduced some subtle comments: the isolation of the door alone in a vast prison-like stone wall; the fragile ladder leading from roof to sky; and the handcart being laboriously dragged up the street, carrying a heavy load in which we recognize the shape of his early wrapped-up object, *L'Enigme d'Isidore Ducasse*. Evidently, he was enjoying himself by reintroducing the enigma in a setting that created a new riddle by its academic style. Although, as I have already remarked, Man Ray insists on his liberty to change his style whenever he sees fit, there is always an authority in his work that gives it its own distinction. Patrick Waldberg has described his conversation with Giacometti in a café where the walls were thickly covered with pretentious works by incompetent artists looking for sales. Giacometti had in his hands a reproduction of a painting by Man Ray, which appeared at first glance rudimentary. Pointing to the works around them, Giacometti said, 'You see, these people know how to do every-thing. Man Ray, he paints as if he knew nothing. But try putting Man Ray in the middle of all that; you will see nothing else but him. All the rest falls down. That's it, the true authority of the spirit.'[65]

119 Making a surprising contrast with *La Rue Férou* is a large picture of the same year entitled *My First Love*. It is completely abstract and very satisfying in its composition and colour. This painting, Man Ray claims, is reminiscent of techniques he discovered in early years, and more than thirty years later he was able to recapture the inspiration of his youth. It is another example of the continuity in spite of diversity that exists throughout his work. Echoes from the past recur frequently, in his childish delight in playing with words and objects, in that 'Alice through the looking-glass' topsy-turvy mixture of innocence and wisdom, which has survived years of trivial and painful events as well as dangerously seductive or sophisticated experiences. What is more, Man Ray knows and affirms with emphasis that the idea of progress cannot be applied to the arts.

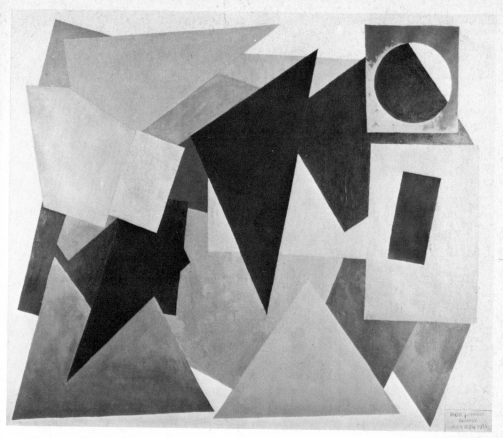

119 *My First Love* 1952

'There is', he says, 'no progress in art, any more than there is in making love.' Speaking of the period after his decision to give up professional photography, he refers in his *Self Portrait* to the anxiety he still felt before setting to work on a new painting,

a sort of misgiving of the outcome of my enterprises. But once engaged in the act, all uncertainty disappeared and I carried on with confidence, with complete assurance.

Whereas photography was simply a matter of calculation, obtaining what had been figured out beforehand, painting was an adventure in which some unknown force might suddenly change the whole aspect of things. The result could be as much a surprise to myself as to a spectator. The surprises produced by a badly-regulated mechanical instrument have no value, but the aberrations of a brain that feels at the same time that it thinks are always interesting.[66]

120 *Image à deux faces* 1959

In saying this, Man Ray is perhaps underestimating the importance of those accidental discoveries which made his photographs a form of art capable of reaching the intensity of painting. This may be due to the flush of enthusiasm he felt for painting on his return to Paris, when he produced out-

p. 158, XVII
p. 183, XVIII,
120
121

standing works such as *Modern Mythology I* and *Modern Mythology II*, *Romeo or Juliet* and *Feminine Painting*, in 1954 and two great paintings, *Les Balayeurs* and *Image à deux faces*, in 1959. The abstract paintings which Man Ray called *Natural Paintings* were made by a process he invented in another burst of originality. He discovered that by applying acrylic paint in heavy patches to a panel and squeezing the still-wet panel against another, he could obtain fascinating effects in colour

121 *Natural Painting* 1958

and texture when the panels were separated. With light-hearted
excitement he produced a series of paintings that sparkle with
colour and the crispness of their textures. They were exhibited
in a small gallery near Saint-Germain-des-Prés in the Spring of
1956, together with other paintings and objects. Once more
Breton wrote a preface to the catalogue, in the form of a poem
which expressed his admiration for the diversity of his friend's
genius:

> *The indoor trapper*
> *The velvety guardian of the grapes of sight*
> *The captor of the sun and the champion of shadows*
> *The great examiner of the scenes of everyday life*
> *The navigator of the never seen and the wrecker of the foreseen*

The prince of the snapshot
The early riser of style
The plasterer of fashion
The pilot of kites – lips and hearts – over our roofs
The spinner of air into as many streamers of Riemann
The despair of the parrot
The inscrutable gambler
My friend Man Ray [67]

This tribute is another proof of the way in which Man Ray surmounted the sectarian squabbles that characterized the group activities of the Surrealists after the war.

Although professional photography became unnecessary and uninteresting for Man Ray, he continued to use photographic processes in one form or another as his tools. His Rayographs had become a universal language and, together with anthologies of his other photographic works, they were widely distributed in publications and exhibitions throughout the world. An impressive retrospective was organized in 1962 by the Bibliothèque Nationale in Paris. Prefaces for the catalogue were written by Julien Cain, the Director, and his Curator, Jean Adhémar. Adhémar wrote in tribute:

Man Ray has done much for the cause of photography not only by his proficiency . . . but also by assimilating photography and painting in an entirely new way. Thanks to him . . . the photographer has been accepted by artists as one of them and Man Ray explains to the painters, to Picasso for instance, that the painter with his eye that 'sees better than we see' is one of the best photographers that exist. [68]

After this homage from the summit of literary institutions, one of Man Ray's photographs was exhibited in 1971 in the midst of the ultimate sanctuary of painting – the Louvre. It was the photograph of Kiki titled *Violon d'Ingres* and, appropriately, it was included in an exhibition centred round the painting that had inspired it – the *Bain turc* of Ingres. It clearly made its point

XVIII *Promenade* 1915, study for *Les Balayeurs* 1959

182

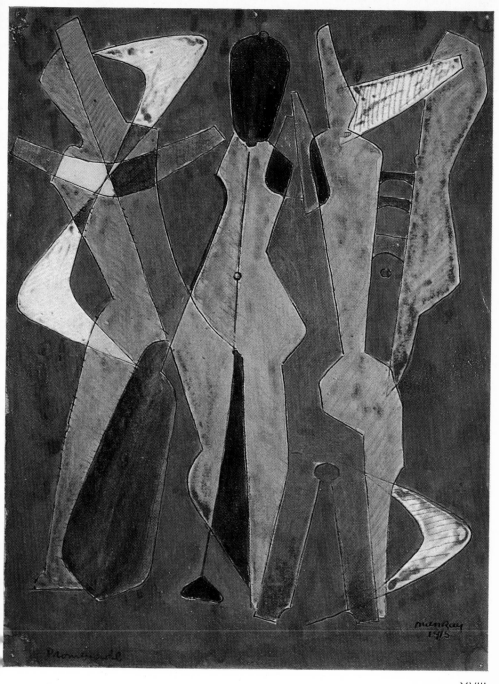

Promenade

manRay
1913

XVIII

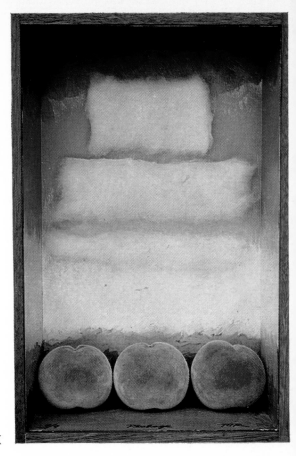

XIX

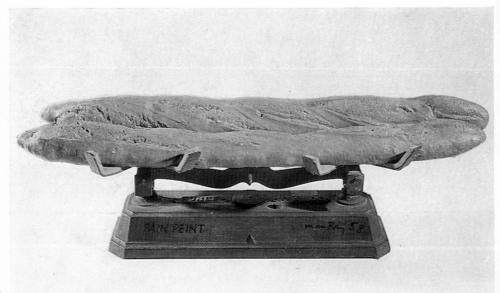

XX

122 From *Les Voies lactées*
1924/73

that photography can have an artistic validity equal to that of painting; the image in both Ingres's painting and Man Ray's photograph is charged with emotional significance.

Following in the wake of the inventions that started with aerographs and continued with Rayographs, solarization and many other less spectacular but still important discoveries, Man Ray has found another device for making his dreams visible by means of a photographic process. The idea came to him as he watched a glass of milk he had just emptied. As the milk left its white streamers inside the glass, he realized he could repeat the effect on a flat photographic plate. From this he made a series of eleven prints of the characteristic and yet unrepeatable designs made by the milk. These prints have recently been published with the title *Les Voies lactées*.[69] The white vertical streams 122

XIX *Péchage* 1969
XX *Pain peint* 1958

made by the milk are, surprisingly, evocative of human bodies intertwined, dancing, embracing or standing erect, packed together like trees in a forest in winter.

The object of the object

Since his return to Paris, Man Ray has become even more prolific in his invention of objects, a pursuit in which he has always found great satisfaction. Throughout, each object has been an independent event rather than part of a sequence, and I find it impossible to do justice in a short space to the great variety of ideas involved. Already certain works, such as the *Cadeau* of 1921, have almost attained the historical importance of Columbus's egg and have entered the public domain in unexpected ways. The image of the *Object to be Destroyed*, for example, was used as an exhortation to awareness and good judgment in the 1974 election campaign of the Hamburg Social Democratic Party, which was presumably unaware of the object's discouraging title. It appeared as the central feature in a poster towering over the roofs of the city, above the slogan 'Choose the Right Timing' (*'Wählt den richtigen Takt'*) and photographs of the S.D.P. candidates, who included the present Chancellor of West Germany. This is an interesting example of Dada nonsense being used as lucid and compelling advice for the masses. With no political intent but more direct significance, the same object has been constructed in monumental proportions for a German collector and was chosen to mark the entrance to an important exhibition of Man Ray's works at the New York Cultural Center in the winter of 1974.

With the exception of a few of the earliest objects, such as the two versions of *By Itself* of 1918 and the *Rebus* of 1925, which belong more to the domain of sculpture, Man Ray has deliberately made a hiatus or even a contradiction between the object and its title. Each work involves three basic factors: the choice of a commonplace object which by its selection becomes more

intriguing; the placing of this in a combination or collage with another object or objects with which it is not usually associated; and the addition of a title which gives a new and unexpected turn to the encounter. The unlikely juxtaposition of objects has its source in the well-known description from Isidore Ducasse of the 'chance encounter of a sewing-machine and an umbrella on a dissecting table', which greatly delighted the Surrealists.

Throughout his work, Man Ray uses frequently these principles of dislocation and confrontation to disturb our normal assessment of reality. He has made objects that are childlike in their simplicity and yet mysteriously disturbing in the surprises they bring. *L'Etoile de verre* of 1965 is no more than 123 a sheet of emery-paper with one horizontal straight line drawn across it and a small glass bead placed in the area above the line, yet the immediate effect it produces is out of all proportion to my description. It becomes for us the great night sky over a dark sea illuminated by the light of one bright star. The title

123 *L'Etoile de verre* 1965

is a simple pun on the words *verre* and *mer*, which also suggests *Etoile de mer*, the starfish, which was the title of the film Man Ray made in the twenties. The title intervenes as the most rudimentary form of humour between the banality of the materials and the cosmic image they evoke. That underrated play on words, the pun, has been shamelessly used by Man Ray all his life. From the beginning he shared with Duchamp an appreciation of its value and the role it can play, not only as a light-hearted play on words, but also as a means of undermining the identity of an object, of bringing about a metamorphosis and altering that which we believe to be reality. A playful slip of the tongue can arouse doubts about the illusion of reality and the reality of illusion, and the objects of Man Ray are the products of a game in which he delights to tease our all-too-rigid belief in reality.

The reality of illusion

To enjoy the work of Man Ray is to enjoy the wide range of illusion he creates. He knows well how to handle magic and does so with clarity and in a practical way. Sometimes it is in simple *trompe-l'œil* drawings in which, on a sheet of paper, he draws a shadow which convincingly throws into relief an object beside it – the reverse of a three-dimensional object casting its own flat shadow. The mask, too, that decisive means of changing the face-value of a person, has provided a constant flow of ideas. Since the early Dada photograph he made of Duchamp disguised as a society lady advertising a non-existent perfume called 'Belle Haleine', Man Ray has played with the ubiquitous human face and changed its composition, its regard and its sense according to his humour. He has decorated masks so that a face becomes a butterfly or grows a plant from the lips; it may turn into an ethereal patch of sky wearing a domino, or into solid mass of pitch. There is no limit to the game of make-believe in which everything is masked. Yet the

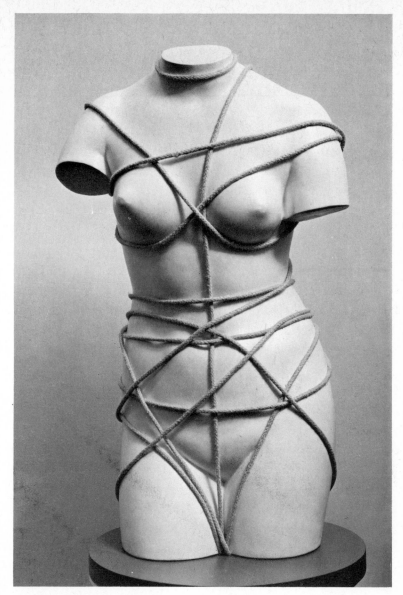

124 *Vénus restaurée* 1936/71

illusions Man Ray achieves are not only visual; they often imply an interrogation of the object itself, which may or may not lead to solutions, but which stimulates our enjoyment by the outrageous simplicity of the illusions. He knows well that to banish illusion is to deny the arts their magic power.

There are several objects as simple and as full of wit as the

126 *Etoile de verre*. *It's Springtime* (1961) consists only of two
mattress-springs twisted into each other at right angles, one

128 vertical and the other horizontal. *Ballet français* (1956) is no more
than a French broom standing on its long handle, cast in bronze

p. 184, XX and realistically painted. *Pain peint* (1960) requires only a change
of colour to make us laugh and wonder – a loaf of French
bread is painted blue. Other, more enigmatic objects include

125 *What We All Lack*, which dates from 1935: a large glass bubble
emerges from the bowl of a churchwarden pipe with 'Ce qui
manque à nous tous' written along its stem. More complex
objects are in the nature of collages which are fascinating in the
choice and arrangement of commonplace objects and in the
illusions created by each part; elsewhere, hallucinatory optical
effects are obtained by lenses, mirrors and fake shadows with
which Man Ray plays with expert knowledge, giving to ideas
borrowed from the funfair a more significant and poetic sense.

127 *Optical Hopes and Illusions* (1944) is particularly remarkable. It is

125 What We All Lack 1935

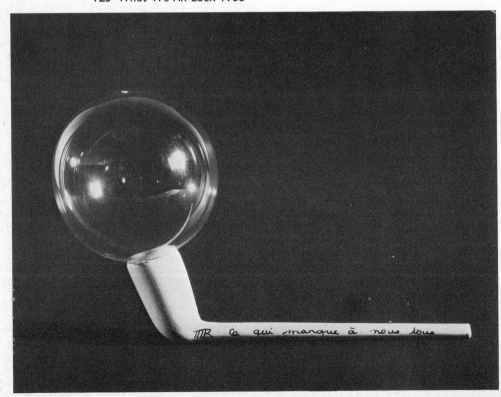

126 *It's Springtime* 1961/71

a banjo set upright, its sound-box gutted and a lens fitted into the resultant hollow circle; behind it, from the top of the neck, hangs a wooden ball that swings to and from the lens. Contrary to our expectation, the ball becomes smaller as it approaches the lens, yet fills the whole circle when it moves away, giving great satisfaction by its contradiction of the laws of perspective.

127 *Optical Hopes and Illusions* 1944

128 *Ballet francais* 1956

The objects of Man Ray have a highly personal flavour and their qualities are very different from those of objects made by other Surrealists such as Miró or, in particular, Picasso, where the metamorphoses produced, such as the bicycle saddle that becomes the head of a bull, have a different significance. In general, Man Ray ignores the aesthetic, sculptural qualities which are always present in the work of Picasso; as Patrick Waldberg writes,

With Man Ray . . . the meaning of the object remains enigmatic or, more precisely, there is in the object, as it were, a suspended meaning; either it remains inexplicable or it offers multiple interpretations, sometimes contradictory, and it is ultimately its mystery that matters. At the object's origin . . . there is the 'almost nothing' that Vladimir Jankelevitch has made the postulate of a poetic philosophy which is singularly seductive.[70]

It is indeed the economy of means, the unsophisticated humour and the absence of pretentiousness, together with the capacity to create 'simple hallucination', that gives to these objects their mysterious and widespread appeal. Man Ray's genius, as Alain Jouffroy says, 'resides in having proved that which men always forget and which defines in history their only true liberty: with nothing, everyone can do all.'[71]

Beyond painting and photography

Whether Man Ray is more French or more American is questionable. He has in fact spent more years of activity in France and had it not been for the war he might not have lived in the States at all after his arrival in Paris at the age of thirty-one. It is in Europe that his reputation has grown steadily, but as an expatriate there is a tendency for him to be neglected in his own country. The memories of frustration during the early years in New York and the estrangement that followed his escape to Paris, when he was known in the States only as a fashion photographer, helped to widen the gap. On his return to

America during the war, his desire to establish himself as a painter was insufficiently rewarded and so he went back to the atmosphere in which he was appreciated and in which his creative urge could thrive.

Yet if we examine the trends in the arts in the United States since the war, there is no lack of evidence that the influence of Man Ray has made itself felt in many ways, unexpectedly and deeply. Man believes, as he has told me, that the reason for Stieglitz's desire to encourage only the most *avant-garde* developments in painting and sculpture was that he considered them to be innocuous to the newly found art of photography. Man Ray, as we have seen, believed the opposite. He considered that photography should be used freely as an adjunct to painting, a legitimate and powerful aid which could introduce unexpected effects; today, the work of Rauschenberg, Warhol and many others is evidence that this attitude has prevailed. Man Ray has pioneered the integration of photography into painting.

In the origins of Pop Art can be found other influences from Man Ray. There can be no denial of the impact of Duchamp and his introduction of ambiguity and multiple levels of meaning in the commonplace objects which comprise his Readymades. Man Ray's contribution in this area is also important, however. Seminal objects such as his *Lampshade*, *New York I* and *New York II*, *Obstruction*, *Cadeau* and *Indestructible Object*, all created before 1923, were completely original in their simple, poetic impact and in the ingenious introduction of another element, movement, into three of them: *Lampshade*, which is rotated by the twisting and untwisting of the thread by which it hangs; *Indestructible Object*, which marks time; and 129 *Obstruction*, a multiple object consisting of an indeterminate number of coat-hangers suspended from each other to resemble a flight of birds.

Man Ray's influence does not depend on the creation of a new style, since his early instinctive revolt against aesthetic

129 *Obstruction* 1920/64

conventions has precluded that possibility; it stems rather from his critical attitude towards the arts and towards life. In the twenties, in drawing and painting, he had the courage to express himself rapidly and vigorously, relying on spontaneity and chance in ways that were prophetic of Abstract Expressionism; drip-painting appears first in *The Telegram* (1929). These methods were of the same nature as the automatic writings of the Surrealists, but Man Ray never limited himself to one system and the image was never entirely absent. He found scope for humour and took delight in totally upsetting our rational sense of scale in paintings such as *The Lovers or Observatory Time*. Of this we find echoes today in the work of Claes Oldenberg, James Rosenquist and Tony Wesselmann, whereas the mystery of the wrapped object appears as early as 1920 in Man Ray's *L'Enigme d'Isidore Ducasse*.

130 *Smoking Device* 1961

The influence of Man Ray increases as his work becomes more widely appreciated. Its most important aspects go beyond painting, photography and objects. Their virtue lies not only in the many techniques he has mastered but also in the subtle and disturbing probes he makes into the nature of life and the directness with which his inventions surprise us. André Malraux wrote recently, quoting from a conversation with Picasso:

We must wake people up. Upset their way of identifying things. It is necessary to create unacceptable images. Make people foam at the mouth. Force them to understand that they live in a mad world. A disquieting world, not reassuring. A world which is not as they see it.[72]

Picasso's exhortation to use mental violence as a means of rejuvenating the spirit has been endorsed throughout by the 'gentle' Man Ray.

The age of light

Man Ray has solved the problem of how to grow old quietly while still remaining young. He continues to preserve his

131 *Le Marteau* 1963

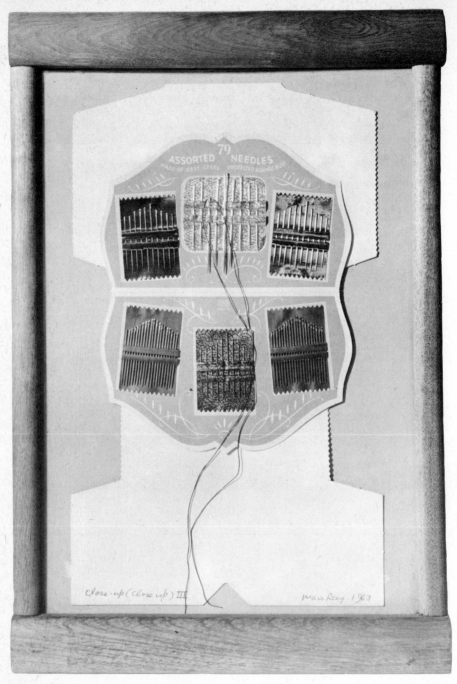

132 *Close-Up (Close Up) III* 1963

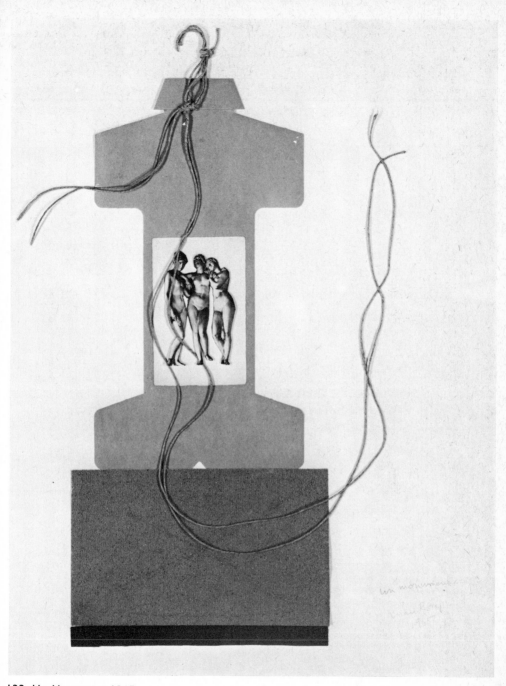

133 *Un Monument* 1965

liberty of thought and action and to enjoy all that life, nourished by the imagination, can offer. He has at last received recognition for the great contributions he has made to art since his early years as a pioneer. In 1961 he was awarded the Gold Medal for Photography at the Venice Biennale, and recent exhibitions of his work have been planned with enthusiasm and understanding on both sides of the Atlantic. The Los Angeles County Museum presented in 1966 the first exhibition which included all aspects of his work. A still more comprehensive show was held at the Boymans Museum in Rotterdam in 1971–2 and was moved to the Musée National d'Art Moderne in Paris the following Spring. Other exhibitions have taken place in many cities throughout Europe, and the New York Cultural Center's retrospective exhibition, which opened in New York in 1974 and travelled from there to London and Turin, proved once again that the genius of Man Ray resides, not only in his painting, his photography and his invention of objects, but in the poetry he instils into all these domains.

It is perhaps as a result of his American upbringing that he has no fear of the 'matter of fact' – that force-fed daily intake of which we are the victims – and is never overcome by romantic sentiment. He finds in the first of these the raw material necessary for his creative processes, while the second, well sifted, is the instinctive source of the emotions and the sense of poetry which appear in his work. He has made between them a marriage of love – one that produces a unique blend, fertile in thought and rich in nourishment for all who desire unrestricted liberty of the spirit and wish to enjoy the enigmatic pleasures of life.

Notes

All translations into English by R. P.

1 Man Ray, *Self Portrait*, London and Boston, 1963; Paris, 1964. (Page references are to the London edition.)

2 ibid., p. 397.

3 ibid., p. 6.

4 Dorothy Norman, *Alfred Stieglitz*, New York, 1972, p. 109.

5 ibid., p. 66.

6 Man Ray, op. cit., p. 18.

7 ibid. p. 20.

8 ibid., p. 22.

9 ibid., p. 39.

10 ibid., p. 44.

11 Dorothy Norman, op. cit., p. 117.

12 ibid., p. 118.

13 loc. cit.

14 Man Ray, op. cit., p. 33.

15 ibid., p. 54.

16 ibid., p. 67.

17 ibid., p. 71.

18 loc. cit.

19 ibid., p. 73.

20 Man Ray, *Revolving Doors*, Turin, 1972.

21 André Breton, *Le Surréalisme et la peinture*, Paris, 1928; New York, 1945; (English edition) *Surrealism and Painting*, London, 1972.

22 Man Ray, *Self Portrait*, p. 108.

23 Louis Aragon, *Le Paysan de Paris*, Paris, 1926, p. 90.

24 Man Ray, *Self Portrait*, p. 93.

25 Patrick Waldberg, *Man Ray: Objets de mon affection,* unpublished manuscript.

26 Man Ray, *Self Portrait*, p. 111.

27 ibid., p. 113.

28 Quoted in Man Ray, *Self Portrait*, p. 113.

29 loc. cit.

30 ibid., p. 115.

31 ibid., p. 129.

32 loc. cit.

33 loc. cit.

34 loc. cit.

35 *Exhibition Rayographes, 1921–1928 L. G. A.*, Stuttgart, 1963.

36 Man Ray, *Self Portrait*, p. 261–2.

37 ibid., p. 118.

38 Man Ray, *The Age of Light: Photographs 1920–1934*, Paris and New York, 1934, p. 42.

39 J. Ribemont-Dessaignes, *Man Ray*, Paris, 1924.

40 André Thirion, *Révolutionnaires sans révolution,* Paris, 1972, p. 148.

41 Man Ray, *Self Portrait*, p. 270.

42 loc. cit.

43 ibid., p. 275.

44 ibid., p. 277.

45 Man Ray, *Electricité: 10 Rayo-graphes*, with an introduction by Pierre Bost, Paris, 1931.

46 Man Ray, *Self Portrait*, p. 255.

47 Man Ray, *The Age of Light*, p. 42.

48 ibid., p. 67.

49 ibid., p. 84.

50 Paul Eluard and Man Ray, *Les Mains libres*, Paris, 1937, p. 176.

51 Eluard and Man Ray, op. cit., p. 9.

52 Man Ray, *La Photographie n'est pas l'art,* Paris, 1937.

53 Man Ray, *Self Portrait,* p. 329.

54 ibid., p. 335.

55 ibid., p. 342.

56 ibid., p. 343.

57 ibid., p. 346.

58 Henry Miller, *Recollections of Man Ray in Hollywood*, unpublished manuscript.

59 Henry Miller, contribution to Man Ray, *La Logique assassine*, unpublished manuscript.

60 Henry Miller, *Recollections of Man Ray in Hollywood*.

61 André Breton, quoted in Man Ray, *To Be Continued Unnoticed*, catalogue of Copley Gallery Exhibition, Los Angeles, 1948.

62 ibid.

63 Marcel Duchamp, *Marchand du sel,* Paris, 1958, p. 44.

64 Man Ray, *Self Portrait,* p. 382.

65 Waldberg, op. cit.

66 Man Ray, *Self Portrait,* p. 384.

67 André Breton, Preface to catalogue of the Man Ray exhibition at L'Etoile Scellée, Paris, 1956.

In the original French, the poem reads:

Le trappeur en chambre
Le duveteur des raisins de la vue
Le capteur de soleil et l'exalteur
 d'ombres
Le grand scrutateur du décor de la
 vie quotidienne
Le boussolier du jamais vu et le
 naufrageur du prévu
Le prince du déclic
Le matinier du goût
Le plafonneur des élégances
Le pilote de ces cerfs-volants –
 lèvres et cœurs – au-dessus de nos
 toits
Le dévideur de l'air en autant de
 serpentins de Riemann
Le désespoir du perroquet
Le joueur impassible
Mon ami Man Ray

68 Man Ray, *L'Œuvre photographique* Paris, 1962.

69 Man Ray, *Les Voies lactées (Milky Ways)*, New York, 1974.

70 Waldberg, op. cit.

71 Alain Jouffroy, catalogue of Man Ray exhibition at the Musée Nationale d'Art Moderne, Paris, 1971.

72 André Malraux, *La Tête d'obsidienne*, Paris, 1974, p. 101.

The Publishers acknowledge permission from Andre Deutsch Ltd and Little, Brown and Company to quote from *Self Portrait*, by Man Ray, Copyright © 1963 by Man Ray.

List of Illustrations

Measurements are given in inches and centimetres, height before width.

Colour Plates

I *Tapestry*, 1911. Wool on canvas, 65 × 45½ (165·1 × 115·6). Collection of the artist. (*Photo:* Museum Boymans-van Beuningen, Rotterdam)

II *Landscape* (*The Village*), 1913. Oil on canvas, 20 × 16 (50·8 × 40·6). Collection of Lucien Scheler, Paris. (*Photo:* Museum Boymans-van Beuningen)

III *AD MCMXIV*, 1914. Oil on canvas, 37 × 69½ (94 × 176·5). Philadelphia Museum of Art. (*Photo:* Museum Boymans-van Beuningen)

IV *Arrangement of Forms, No. I*, 1915. Oil on canvas, 17½ × 11½ (44·5 × 29·2). Collection of the artist. (*Photo:* Museum Boymans-van Beuningen)

V *The Rope-Dancer Accompanies Herself With Her Shadows*, 1916. Oil on canvas, 52 × 73¾ (132·1 × 186·4). The Museum of Modern Art, New York. (*Photo:* Museum Boymans-van Beuningen)

VI *La Volière*, 1919. Aerograph, gouache on paper, 28 × 22 (71·1 × 55·9). Private collection, London. (*Photo:* Museum Boymans-van Beuningen)

VII *Symphony Orchestra*, 1916. Oil on canvas, 52 × 36 (132·1 × 91·4). Albright-Knox Art Gallery, Buffalo, New York, George B. and Jenny R. Mathews Fund. (*Photo:* Gallery)

VIII *Orchestra*, 1916–17/42. Oil on canvas, 30 × 20 (76·2 × 50·8). From the *Revolving Doors* series; this is a version in oil of the earlier collage. Galleria Il Fauno, Turin. (*Photo:* Gallery)

IX *Mime*, 1916–17/42. Oil on canvas, 30 × 20 (76·2 × 50·8). From the *Revolving Doors* series; this is a version in oil of the earlier collage. Galleria Il Fauno, Turin. (*Photo:* Gallery)

X *The Lovers or Observatory Time*, 1932–4. Oil on canvas, 39⅜ × 98⅝ (100 × 250·5). Collection of William N. Copley, New York.

XI *La Fortune*, 1938/41. Oil on canvas, 20 × 24 (50·8 × 61). This is a later version of the 1938 painting.

XII *The Misunderstood One*, 1938. Oil on canvas, 24 × 18 (61 × 45·7). Collection of the artist. (*Photo:* Museum Boymans-van Beuningen)

XIII *Le Beau Temps*, 1939. Oil on canvas, 112 × 108 (284·5 × 274·3). Collection of the artist. (*Photo:* Museum Boymans-van Beuningen)

XIV *Retour à la raison*, 1939. Oil on canvas, 78⅝ × 50¾ (200 × 129). Moderne Kunsthandels Anstalt, Zürich. (*Photo:* Museum Boymans-van Beuningen)

XV *Merry Wives of Windsor*, 1948. Oil on canvas, 24 × 18 (61 × 45·7). Galleria Il Fauno, Turin.

XVI *La Rue Férou*, 1952. Oil on canvas, 30½ × 23½ (77·5 × 59·7). Collection of Samuel Siegler, New Jersey. (*Photo:* Museum Boymans-van Beuningen)

XVII *Modern Mythology II*, 1956. Oil on canvas, 57½ × 44⅞ (146 × 114). Studio Marconi, Milan. (*Photo:* Museum Boymans-van Beuningen)

XVIII *Promenade*, 1915. Oil on canvas, 24 × 19½ (61 × 49·5). Study for *Les Balayeurs*, 1959. Collection of M. J. Daniel Weitzman, Southampton, New York. (*Photo:* Museum Boymans-van Beuningen)

XIX *Péchage*, 1969. Mixed media object, 9 × 14 × 4 (22·9 × 26 × 10·2). Galleria Il Fauno, Turin. (*Photo:* Museum Boymans-van Beuningen)

XX *Pain peint*, 1958. Polyester, 29½ (75) long. Collection of Marcel Zerbib, Paris. (*Photo:* Museum Boymans-van Beuningen)

Monochromes

1 *Portrait*, 1909. Oil on canvas, 18⅛ × 15 (46 × 38). Collection of the artist. (*Photo:* Galleria Il Fauno)

2 Man Ray with his mother, 1895. (*Photo:* Galleria Il Fauno)

3 *Dancer* (*Danger*), 1920. Engraving on glass, 6¾ × 4⅜ (17·1 × 11·1). Galleria Schwarz, Milan.

4 *Drawing*, 1912. Ink, now lost.

5 *Portrait of Stieglitz*, 1913. Oil on canvas, 10½ × 8½ (26·7 × 21·6). Yale University Art Gallery, Alfred Stieglitz Archive. (*Photo:* Gallery)

6 *Spiral Poem*, 1919. Page 1 of *La Logique assassine*, published privately by Man Ray.

7 *Portrait of Donna*, 1914. Ink on paper, 17½ × 11⅛ (44·5 × 29·5). Galleria Il Fauno, Turin. (*Photo:* Gallery)

8 *Self-Portrait*, 1914. Ink on paper, 12¼ × 16½ (31 × 41·9). Galleria Il Fauno, Turin. (*Photo:* Gallery)

9 *Trees*, 1914. Ink on card, 8⅛ × 8⅛ (20·6 × 20·6). Galleria Il Fauno, Turin. (*Photo:* Gallery)

10 *The Rug*, 1914. Oil on canvas, 18½ × 20½ (47 × 52·1). Galleria Il Fauno, Turin. (*Photo:* Museum Boymans-van Beuningen)

11 *Totem*, 1914. Oil on canvas, 35⅝ × 24⅛ (90·8 × 61·2). Cordier and Ekstrom, Inc., New York. (*Photo:* Museum Boymans-van Beuningen)

12 *Man Ray*, 1914. Oil on canvas, 7⅛ × 5⅛ (18·1 × 13). Private collection, London. (*Photo:* Museum Boymans-van Beuningen)

13 *Drawing*, 1915. Charcoal, 24⅝ × 19 (62·5 × 48·3). Museum of Modern Art, New York, Mr and Mrs Donald B. Straus Fund. (*Photo:* Museum)

14 *Black Widow*, 1916. Oil on canvas, 70⅞ × 34¼ (180 × 87). Collection of Marcel Zerbib, Paris. (*Photo:* Galleria Schwarz)

15 *Self-Portrait*, 1916. Silk screen on plexiglass, 28 × 19 (71·1 × 48·3). Galerie Georges Visat, Paris. (*Photo:* Gallery)

16 *Legend*, 1916. Oil on canvas, 24¼ × 18¼ (61·6 × 46·4). Collection of Baron J. B. Urvater, Paris. (*Photo:* Jacqueline Hyde)

17 *Dance*, 1915. Oil on canvas, 36 × 28 (91·4 × 71·1). Collection of William N. Copley, New York. (*Photo:* W. N. Copley)

18 *Theatr*, 1916. Collage, 17⅝ × 24 (44·8 × 61). Moderna Museet, Stockholm. (*Photo:* Museum Boymans-van Beuningen)

19 *Suicide*, 1917. Airbrushed tempera on cardboard, 23½ × 18 (59·7 × 45·7). Private collection, U.S.A. (*Photo:* A. Mewbourn)

20 *The Rope-Dancer Accompanies Herself With Her Shadows*, 1917. Aerograph, 13⅜ × 17⅜ (34 × 44·1). Collection of Mr and Mrs M. G. Neumann, Chicago. (*Photo:* Museum Boymans-van Beuningen)

21 *Admiration of the Orchestrelle for the Cinematograph*, 1919. Aerograph, 26 × 21½ (66 × 54·6). The Museum of Modern Art, New York, gift of A. Conger Goodyear. (*Photo:* Museum)

22 *Involute*, 1917. Collage, 24 × 18 (61 × 45·7). Private collection, London.

23 *Jazz*, 1919. Aerograph, 27¼ × 21¼ (69·2 × 54). The Columbus Gallery, Ohio, Howald Collection. (*Photo:* Gallery)

24 *Hermaphrodite*, 1919. Aerograph, 20 × 16¼ (50·8 × 41·3). Private collection, London. (*Photo:* Galleria Il Fauno)

25 *Untitled*, 1919. Aerograph, 29½ × 23½ (74·9 × 59·7). Private collection, London.

26 *New York I*, 1917/66. Silver, height 18 (45·7), base diameter 9½ (24), after the original in wood of 1917. Collection of Marcel Zerbib, Paris. (*Photo:* Galleria Schwarz)

27 *By Itself I*, 1918/66. Bronze, height 16½ (41·9), base 3¼ × 3½ (8·3 × 8·9). On the back it reads, '"Sculpture" By Itself I, Man Ray 1918', after the original in wood of 1918. Collection of Marcel Zerbib, Paris. (*Photo:* Galleria Schwarz)

28 *By Itself II*, 1918/66. Bronze, height 23 (58·4), base 3¼ × 3¼ (8·3 × 8·3). On the back it reads, '"By Itself" II, Man Ray 1918', after the original in wood of 1918. Collection of Marcel Zerbib, Paris. (*Photo:* Galleria Schwarz)

29 *Rebus*, 1925. Bronze, 8¾ × 11 (22·2 × 27·9). There are several reproductions of this work.

30 *Elevage de poussière*, 1920. The original photograph, dating from 1920, was made in collaboration with Marcel Duchamp. Photograph, 9¼ × 12 (23·5 × 30·5). Galleria Schwarz, Milan. (*Photo:* Gallery)

31 Man Ray in New York, 1919. (*Photo:* Galleria Il Fauno)

32 *Self-Portrait*, 1933. Solarized photograph.

33 *Cadeau*, 1921/63. Flat-iron with nails, 6 × 3½ (15·2 × 8·9). Collection of the artist. (*Photo:* Galleria Il Fauno)

34 *Boardwalk*, 1917/73. Collage, 26⅜ × 28¾ (67 × 73). Staatsgalerie, Stuttgart.

35 *Compass*, 1920. Mixed media, 4⅝ × 3¼ (11·7 × 8·3). There are several versions of this work.

36 *Coatstand*, 1920. Photograph, 9¾ × 6¾ (24·8 × 17·1). Galleria Schwarz, Milan. (*Photo:* Gallery)

37 *Transatlantic*, 1920. Photograph, 8⅞ × 11½ (22·5 × 29·2). Galleria Il Fauno, Turin. (*Photo:* Gallery)

38 *Bubble Emerging from Clay Pipe, and Frosted Leaf*, 1947. Rayograph, 15¾ × 11¾ (40 × 29·8). Collection of Timothy Baum.

39 *Circular Objects in Motion, with Tacks, Spring and Electric Plug*, 1922. Rayograph, 9⅜ × 7 (23·8 × 17·8). Collection of Timothy Baum.

40 *Kiki Drinking*, 1922. Rayograph, 9⅜ × 7 (23·8 × 17·8), from *The Age of Light: Photographs 1920–1934*, Paris and New York, 1934, p. 93.

41 Rayograph, 10⅜ × 8¼ (26·4 × 21), from *The Age of Light*, p. 100.

42 Rayograph, 10⅝ × 7⅞ (27 × 20), from *The Age of Light*, p. 101.

43 *L'Echiquier surréaliste*, 1934. Photomontage, 18⅛ × 11⅞ (46 × 30·2). Galleria Schwarz, Milan. (*Photo:* Enrico Cattaneo)

44 At Tzara's, 1930. Left to right, back row: Tzara, Arp, Tanguy and Crevel; in front: Eluard, Breton, Dali, Ernst and Man Ray. (*Photo:* Galleria Il Fauno)

45 *L'Enigme d'Isidore Ducasse*, 1920. Photograph, 9¼ × 11⅞ (23·5 × 29·5). Galleria Il Fauno, Turin. (*Photo:* Gallery)

46 *Portrait of Kiki*, 1924. Ink 7½ × 9¼ (19·1 × 23·5). Collection of Erica Brausen. (*Photo:* Museum Boymans-van Beuningen)

47 *Violon d'Ingres*, 1924. Photograph, 15¾ × 11¾ (40 × 29·8). Galleria Il Fauno, Turin. (*Photo:* Gallery)

48 *La Marchesa Casati*, 1922. Photograph. (*Photo:* Eileen Tweedy)

49 Man Ray in his first car, 1926. (*Photo:* Galleria Il Fauno)

50 At the château of the Noailles, 1929. (*Photo:* Galleria Il Fauno)

51 Man Ray and Robert Desnos, 1928. (*Photo:* Galleria Il Fauno)

52 Frames from *Emak Bakia*, 1926. Motion picture. (*Photo:* Galleria Il Fauno)

53 *Portrait of Lee Miller*, 1930. Solarized photograph, $11 \times 8\frac{3}{8}$ (27·9 × 21·3), from *The Age of Light*, p. 52.

54 *Portrait of Julie*, 1954. Photograph, $6\frac{1}{4} \times 4\frac{1}{4}$ (15·9 × 10·8). (*Photo:* Galleria Il Fauno)

55 *La Ville*, 1931. Photograph, $10\frac{1}{4} \times 8\frac{1}{8}$ (26 × 20·6). From *Electricité: 10 Rayographes*, Paris, 1931. (*Photo:* Galerie Maeght)

56 *Untitled*, 1931. Photograph, $10\frac{1}{4} \times 8\frac{1}{8}$ (26 × 20·6). From *Electricité: 10 Rayographes*. (*Photo:* Galerie Maeght)

57 *Cuisine*, 1931. Photograph, $10\frac{1}{4} \times 8\frac{1}{8}$ (26 × 20·6). From *Electricité: 10 Rayographes*. (*Photo:* Galerie Maeght)

58 *Untitled*, 1931. Photograph, $10\frac{1}{4} \times 8\frac{1}{8}$ (26 × 20·6). From *Electricité: 10 Rayographes*. (*Photo:* Galerie Maeght)

59 *The Lovers or Observatory Time*, the canvas above the divan in the rue du Val de Grâce. At the left is one of the original chess sets. (*Photo:* Galleria Il Fauno)

60 *La Prière*, 1930. Photograph, $12\frac{5}{8} \times 9\frac{1}{8}$ (32·1 × 23·2). Collection of the artist.

61 *Portrait of Kiki*, 1923. Oil on canvas, 24×18 (61 × 45·7). Collection of Mr and Mrs David Savage, Princeton.

62 *Portrait of Duchamp*, 1923. Oil on canvas, $23\frac{1}{4} \times 19\frac{1}{2}$ (59·1 × 49·5). Galleria Il Fauno, Turin. (*Photo:* Gallery)

63 *Swedish Landscape*, 1924–5. Oil on canvas, $18\frac{1}{8} \times 9\frac{1}{2}$ (46 × 24). Collection of Mme Simone Collinet, Paris. (*Photo:* Courtesy of Mme Collinet)

64 *Indestructible Object*, 1923/58. Metronome and photograph, height $9\frac{1}{4}$ (23·5). Collection of the artist. (*Photo:* Galleria Schwarz)

65 *Lampshade*, 1919/59. Twisted tin, $96\frac{1}{2}$ (245·1). Galleria Schwarz, Milan. (*Photo:* Gallery)

66 *Self-Portrait*, 1932. Bronze, $14\frac{3}{4} \times 8\frac{1}{4}$ (37·5 × 21). Galleria Schwarz, Milan. (*Photo:* Attilio Bacci)

67 *Mire universelle*, 1933/71. Plaster and wood, $26 \times 20\frac{1}{8} \times 7\frac{7}{8}$ (66 × 51·1 × 20). Collection of Marcel Zerbib, Paris. (*Photo:* Attilio Bacci)

68 *Emak Bakia*, 1927/70. Silver, height $18\frac{1}{8}$ (46). Studio Marconi, Milan. (*Photo:* Enrico Cattaneo)

69 *Profile and Hands*. Solarized photograph. (*Photo:* Nathan Rabin)

70 *Portrait*, 1933. Solarized photograph. (*Photo:* Galleria Il Fauno)

71 Solarized photograph, 1932. $9 \times 11\frac{3}{8}$ (22·9 × 28·9), from *The Age of Light*, p. 21. (*Photo:* Galleria Il Fauno)

72 Photograph, $8\frac{1}{4} \times 6\frac{1}{8}$ (21 × 15·5), from *The Age of Light*, p. 1.

73 Photograph, $11 \times 8\frac{1}{2}$ (27·9 × 21·6), from *The Age of Light*, p. 3.

74 Photograph, $7\frac{1}{8} \times 9\frac{1}{8}$ (18·1 × 23·2), from *The Age of Light*, p. 17.

75 Photograph, $9\frac{1}{8} \times 7\frac{5}{8}$ (23·2 × 19·4), from *The Age of Light*, p. 25.

76 Solarized photograph, $11 \times 8\frac{3}{4}$ (27·9 × 22·2), from *The Age of Light*, p. 38.

77 Solarized photograph, $11 \times 8\frac{3}{4}$ (27·9 × 22·2), from *The Age of Light*, p. 39.

78 Solarized photograph, $6\frac{1}{2} \times 8\frac{3}{4}$ (16·5 × 22·2), from *The Age of Light*, p. 40.

79 Page 4 from *Facile*, Paris, 1935. $4\frac{7}{8} \times 7\frac{1}{8}$ (12·4 × 18·1).

80 Page 5 from *Facile*, $4\frac{7}{8} \times 7\frac{1}{8}$ (12·4 × 18·1).

81 Page 7 from *Facile*, $4\frac{7}{8} \times 7\frac{1}{8}$ (12·4 × 18·1).

82 Page 8 from *Facile*, $4\frac{7}{8} \times 7\frac{1}{8}$ (12·4 × 18·1).

83 *Collage, ou l'age de la colle*, 1935. Mixed media, 25×19 (63·5 × 48·3). Private collection, London. (*Photo:* Cross Brothers)

84 *The Poet (King David)*, 1938. Oil, $21\frac{3}{4} \times 18\frac{1}{8}$ (55·2 × 46). Collection of Marcel Zerbib, Paris. (*Photo:* Museum Boymans-van Beuningen)

85 *Easel Painting*, 1938. Oil on canvas, 112×108 (284·5 × 274·3). Collection of the artist. (*Photo:* Galleria Schwarz)

86 *Le Chevalier rouge*, 1938. Oil on canvas, 50×35 (127 × 88·9). Collection of Mr and Mrs D. L. Kreeger, Washington, D.C.

87 *The Woman and Her Fish (Pisces)*, 1938. Oil on canvas, $23\frac{5}{8} \times 35$ (60 × 88·9). Tate Gallery, London. (*Photo:* Gallery)

88 *Imaginary Portrait of D. A. F. de Sade*, 1938. Oil on canvas, $21\frac{5}{8} \times 17\frac{3}{4}$ (54·9 × 45·1). Collection of William N. Copley, New York.

89 *Les Tours d'Eliane*, 1936. Ink, $10\frac{1}{4} \times 7\frac{1}{2}$ (26 × 19), from *Les Mains libres*, Paris, 1937, p. 156.

90 *Où se fabriquent les crayons*, 1936. Ink, $7\frac{1}{8} \times 10\frac{1}{4}$ (18·1 × 26), from *Les Mains libres*, p. 168.

91 *Le Tournant*, 1936. Ink, $10\frac{1}{4} \times 7\frac{1}{4}$ (26 × 18·4), from *Les Mains libres*, p. 84.

92 *The Bridge*, 1937. Ink, $8\frac{1}{2} \times 11$ (21·6 × 27·9), from *Les Mains libres*, p. 1.

93 *Belle Main*, 1937. Ink, $10\frac{1}{4} \times 8\frac{1}{2}$ (26 × 21·6), from *Les Mains libres*, p. 96.

94 *Le Don*, 1937. Ink, $10\frac{3}{8} \times 8\frac{1}{2}$ (26·4 × 21·6), from *Les Mains libres*, p. 32.

95 *Self-Portrait*, 1936. Ink, $11 \times 8\frac{3}{4}$ ($27\cdot9 \times 22\cdot2$). Collection of Mr and Mrs David Savage, Princeton.

96 *Photographie intégrale et cent pour cent automatique*, 1937. Photograph, $5\frac{5}{8} \times 4\frac{7}{8}$ ($14\cdot3 \times 12\cdot4$), from *La Photographie n'est pas l'art*, Paris, 1937.

97 *Infinite Man*, 1942. Oil on canvas, 72×50 ($182\cdot9 \times 127$). Studio Marconi, Milan. (*Photo:* Enrico Cattaneo)

98 Juliet, 1946. (*Photo:* Galleria Il Fauno)

99 Man Ray in Hollywood, 1948. (*Photo:* Galleria Il Fauno)

100 *Le Témoin*, 1941. Cardboard, $10\frac{1}{2} \times 24$ ($26\cdot7 \times 61$). Galleria Schwarz, Milan. (*Photo:* Attilio Bacci)

101 *Repainted Mask*, 1941. Papiermâché, 17×20 ($43\cdot2 \times 50\cdot8$). Of this, Man Ray wrote: 'The same satisfaction that attends normal make-up can be carried further by a complete transformation of facial anatomy, borrowing motives from nature.'

102 *L'A*, 1941. Oil on panel, $8\frac{5}{8} \times 6\frac{1}{4}$ (22×16). Collection of M. Cesare Tosi, Milan.

103 *Domesticated Egg*, 1944. Wood, $4\frac{3}{4} \times 14\frac{7}{8} \times 4\frac{1}{4}$ ($12\cdot1 \times 37\cdot8 \times 10\cdot8$). Signed and dated on the back: 'Man Ray 1944'. Collection of Mr and Mrs Julian Levy, Bridgewater, Connecticut.

104 *Picture with a Handle*, 1943. Oil on canvas, with wooden handles.

105 *Mr Knife and Miss Fork*, 1944. Mixed media object, $9\frac{1}{8} \times 13\frac{3}{8} \times 1\frac{5}{8}$ ($23\cdot2 \times 34 \times 4\cdot1$). Collection of Mr and Mrs David Savage, Princeton.

106 Man Ray and Ava Gardner, 1950. (*Photo:* Galleria Il Fauno)

107 *Knight's Move*, 1946. Oil on hardboard, 14×14 ($35\cdot6 \times 35\cdot6$). Private collection, London.

108 *Cactus*, 1946. Oil on canvas, 38×30 ($96\cdot5 \times 76\cdot2$). Private collection, London.

109 *Hamlet*, 1949. Oil on canvas, $16\frac{1}{2} \times 20$ ($41\cdot9 \times 50\cdot8$). Collection of Lockwood Thompson. (*Photo:* by courtesy of Lockwood Thompson)

110 *Macbeth*, 1948. Oil, 30×24 ($76\cdot2 \times 61$). Collection of Timothy Baum. (*Photo:* Walter Dräyer)

111 *Romeo or Juliet*, 1954. Oil, $31\frac{7}{8} \times 23\frac{1}{2}$ ($81 \times 59\cdot7$). Collection of the artist.

112 The studio in the rue Férou. (*Photo:* Galleria Il Fauno)

113 Man Ray and Juliet with Picasso, his wife Jacqueline and a friend, 1956. (*Photo:* Galleria Il Fauno)

114 *Aline and Valcour*, 1950. Oil on canvas, 30×38 ($76\cdot2 \times 96\cdot5$). Collection of the artist.

115 Man Ray at Cadaques, Spain, 1963. (*Photo:* Galleria Il Fauno)

116 Man Ray and Marcel Duchamp. (*Photo:* Henri Cartier-Bresson)

117 Chess Set. Aluminium. There are several versions of this set, in varying sizes.

118 *Belle Haleine – Eau de voilette*, 1920. Photograph, $10 \times 6\frac{7}{8}$ ($25\cdot4 \times 17\cdot5$). Galleria Il Fauno, Turin. (*Photo:* Gallery)

119 *My First Love*, 1952. Oil on canvas, $74\frac{7}{8} \times 89$ ($190\cdot2 \times 226\cdot1$). Collection of the artist.

120 *Image à deux faces*, 1959. Oil on canvas, $78\frac{3}{4} \times 59$ ($200 \times 149\cdot9$). Galleria Il Fauno, Turin.

121 *Natural Painting*, 1958. Oil on masonite, $17\frac{7}{8} \times 23\frac{7}{8}$ ($45\cdot5 \times 60\cdot8$). Galleria Il Fauno, Turin. (*Photo:* Gallery)

122 From *Les Voies lactées*, 1924/73. Milk on photographic plate. Iolas Gallery, New York.

123 *L'Etoile de verre*, 1965. Polished glass on emery paper, $9\frac{1}{2} \times 13$ ($24\cdot1 \times 33$). Collection of Marcel Zerbib, Paris. (*Photo:* Attilio Bacci)

124 *Vénus restaurée*, 1936/71. Plaster and rope, height 28 ($71\cdot1$). Galleria Schwarz, Milan.

125 *What We All Lack*, 1935. Glass bubble on china pipe, $7\frac{7}{8} \times 6\frac{3}{8}$ ($20 \times 16\cdot2$). Collection of Marcel Zerbib, Paris.

126 *It's Springtime*, 1961/71. Two springs on wooden base, height 28 ($71\cdot1$), base $12\frac{1}{4} \times 11\frac{3}{8}$ ($31\cdot1 \times 28\cdot9$). Collection of Morton G. Neumann, Chicago. (*Photo:* Attilio Bacçi)

127 *Optical Hopes and Illusions*, 1944. Wood and magnifying glass, $21\frac{3}{8} \times 7\frac{3}{4} \times 3\frac{7}{8}$ ($54\cdot3 \times 19\cdot7 \times 9\cdot8$). Collection of Patricia Kane Matisse, New York.

128 *Ballet français*, 1956. Painted bronze, $33\frac{1}{2} \times 9\frac{1}{8}$ ($85\cdot1 \times 23\cdot2$). Galleria Schwarz, Milan. (*Photo:* Attilio Bacci)

129 *Obstruction*, 1920/64. Sixty-three coathangers. Galleria Schwarz, Milan. (*Photo:* Enrico Cattaneo)

130 *Smoking Device*, 1961. Mixed media, $8\frac{3}{4} \times 8\frac{7}{8}$ ($22\cdot2 \times 22\cdot5$). Galleria Schwarz, Milan. (*Photo:* Attilio Bacci)

131 *Le Marteau*, 1963. Bakelite and sandpaper on hardboard, $21\frac{1}{2} \times 16\frac{1}{8}$ ($54\cdot6 \times 41$). Galleria Schwarz, Milan. (*Photo:* Attilio Bacci)

132 *Close-Up (Close Up) III*, 1963. Paper and needles, 14×10 ($35\cdot6 \times 25\cdot4$). Galleria Schwarz, Milan. (*Photo:* Attilio Bacci)

133 *Un Monument*, 1965. Collage, $25 \times 19\frac{3}{4}$ ($63\cdot5 \times 50\cdot2$). Signed and dated at bottom right: 'Un monument Man Ray 1965'. Hanover Gallery, London.

FALL 77

INVENTORY 1983